Kitchener Ontario Book 2 in Colour Photos, Saving Our History One Photo at a Time

Photography
by Barbara Raué
2013

Series Name:
Cruising Ontario

Book 43: Kitchener Book 2

Cover photo: 73 Queen Street North, Prosecutors Office

Series Name: Cruising Ontario
Saving Our History One Photo at a Time

Photos now in full colour
Check the Appendixes in the back of each book for
descriptions of architectural terms and building styles

 Book 33: Southampton
 Book 34: Jarvis
 Book 35: Hagersville
 Book 37: Simcoe
 Book 38: Galt Book 1
 Book 39: Galt Book 2
 Book 40: Preston
 Book 41: Hespeler
 Book 42: Kitchener Book 1
 Book 43: Kitchener Book 2
 Book 46: Shelburne
 Book 50: Orangeville Beginnings
 Book 51: Orangeville on Broadway

Other Books by Barbara Raue

Coins of Gold

Arrows, Indians and Love

The Life and Times of Barbara
Volume 1: Inventions That Have Enhanced My Life
Volume 2: Entertainment That I Have Enjoyed
Volume 3: East Coast Trips
Volume 4: Olympics Have Always Intrigued Me
Volume 5: Wonders of the World
Volume 6: Caribbean Cruises We Have Enjoyed
Volume 7: Animals
Volume 8: Storms and Other Major Disasters in My Lifetime
Volume 9: Wars, Terrorist Attacks and Major Disasters

The Cromwell Family Book

Visit Barbara's website to view all of her books
http://barbararaue.ericraue.com

Kitchener

Joseph Schneider, his wife Barbara and their four children arrived in the area in 1807. They were among a small group of rugged pioneers who trekked to the new frontier from Lancaster County, Pennsylvania in search of arable farmland. They found what they were looking for but they also found an intimidating landscape of uncleared bush, swampland and sandhills.

Bolstered by their Mennonite religion and assisted by their closely-knit brotherhood, these hardy settlers adapted quickly to their new life. By 1816 Joseph Schneider had erected a sawmill and a substantial Georgian-style wood-frame home for his family. He had cleared a road, Schneider's Road, that linked his farm to the Great Road through the German Company Tract and had completed his family with three more children.

Rye bread was a staple of local Mennonites' diet. Drying was a standard way for the women to preserve fruits and vegetables. Several bushels of apples could be dried at the same time. The large brick oven could bake quantities of pies, cakes, puddings and even dry fruits at the same time so that the housewife only had to bake once a week.

Schneider's original 448 acre farm has shrunk to less than an acre, Victoria Park occupies the land where the sawmill once stood and Schneider's Road is now called Queen Street. Even the town of Berlin has been renamed Kitchener.

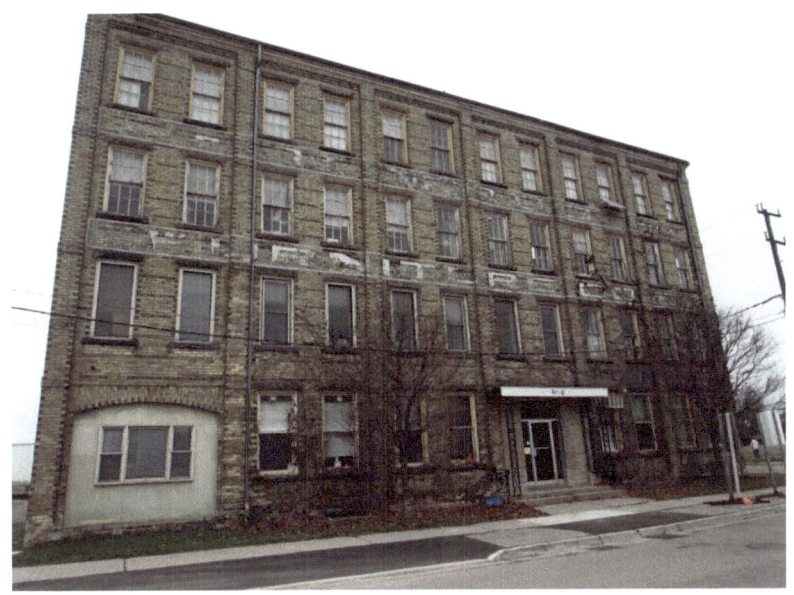

H. Krug Furniture Company Limited factory

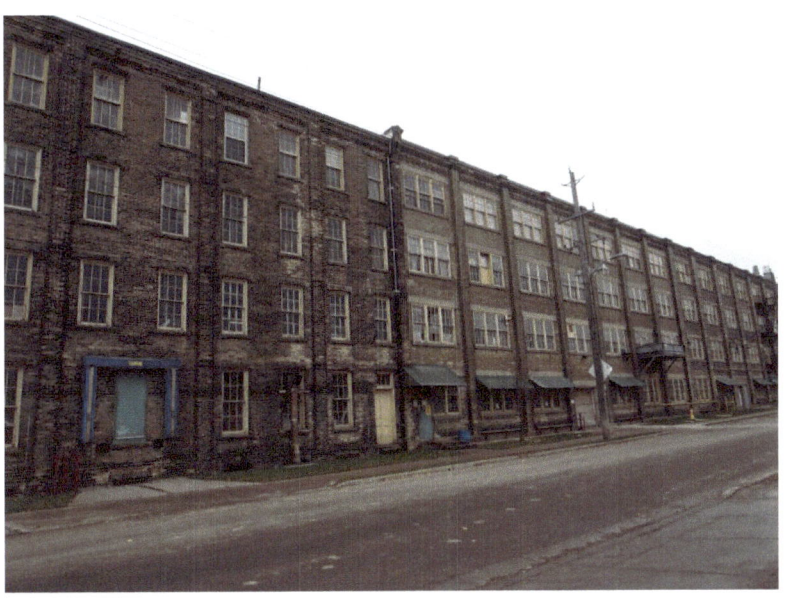

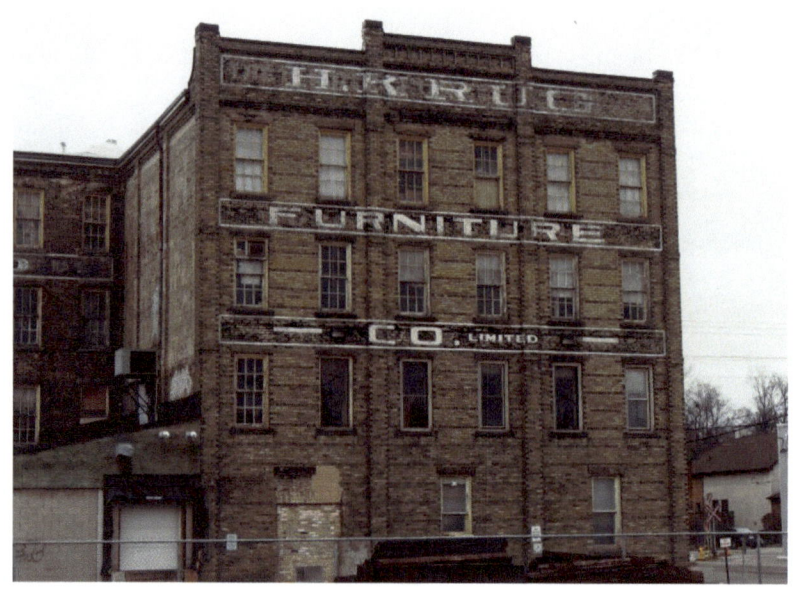

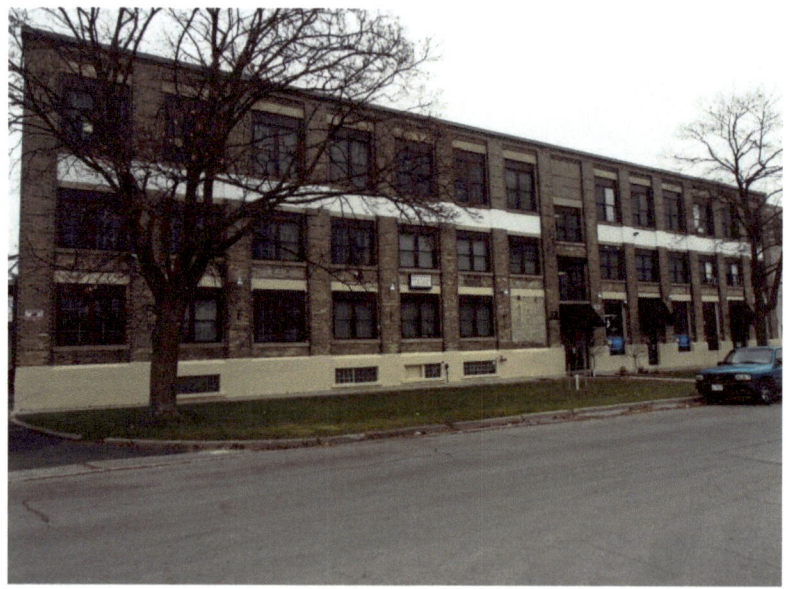

72 Ahrens Street

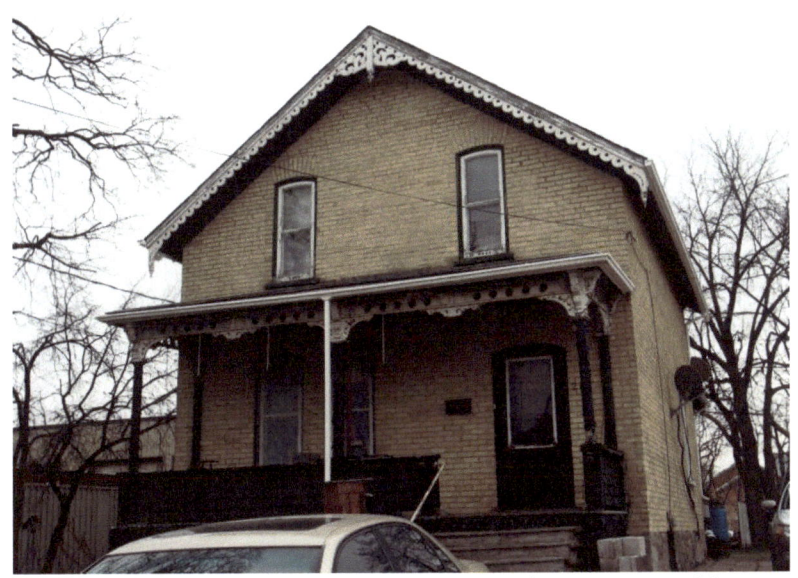

21 Ahrens Avenue – Vergeboard trim on gable

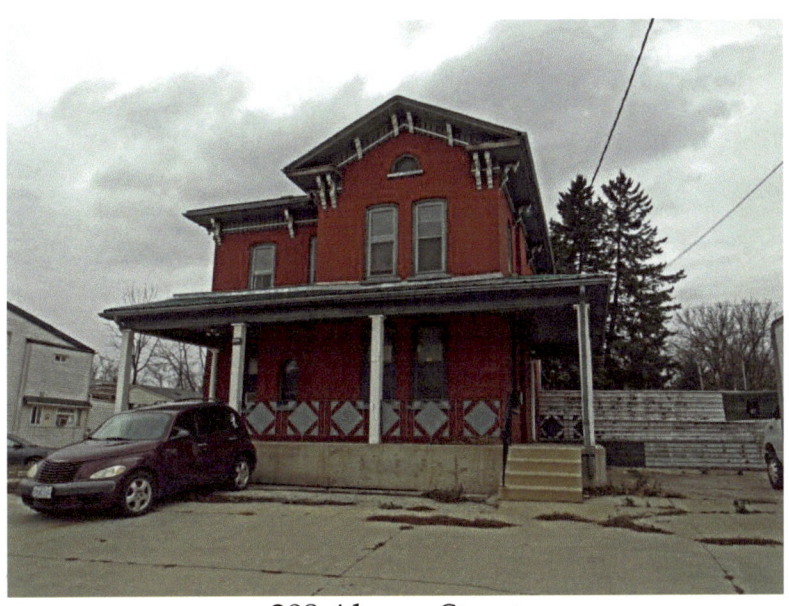

208 Ahrens Street

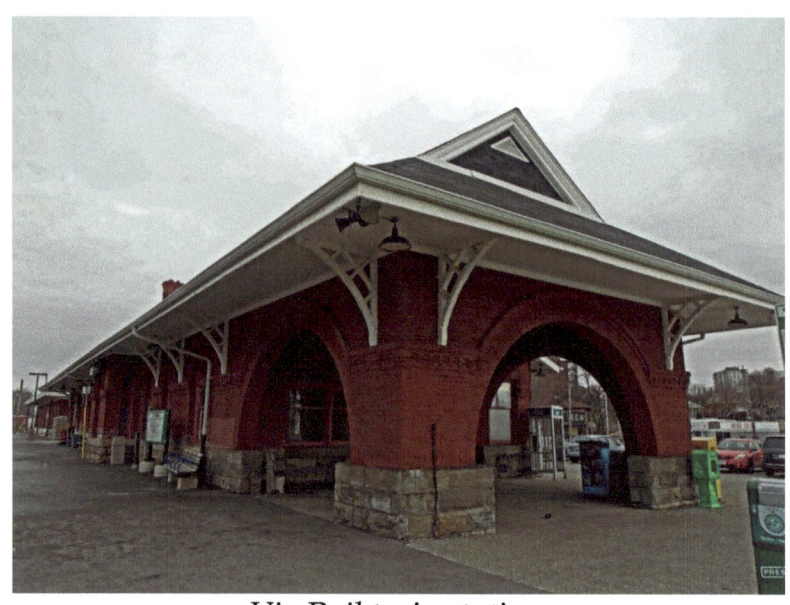

Via Rail train station

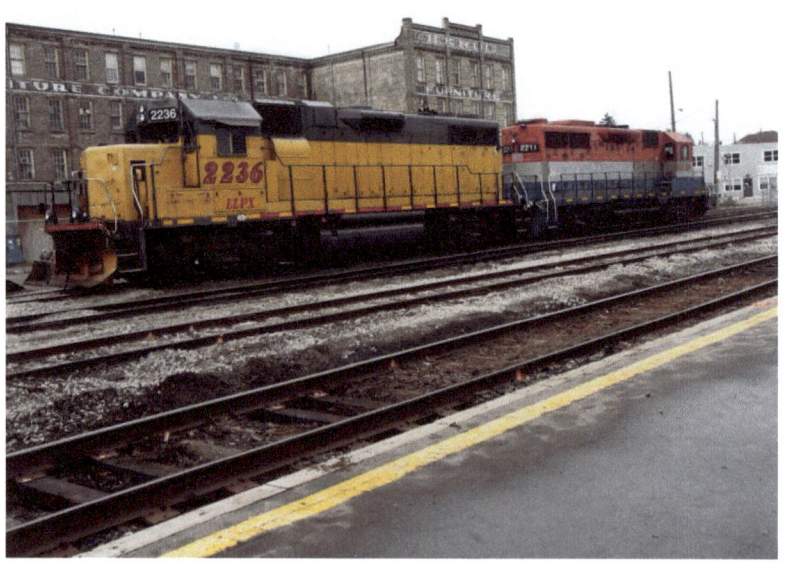

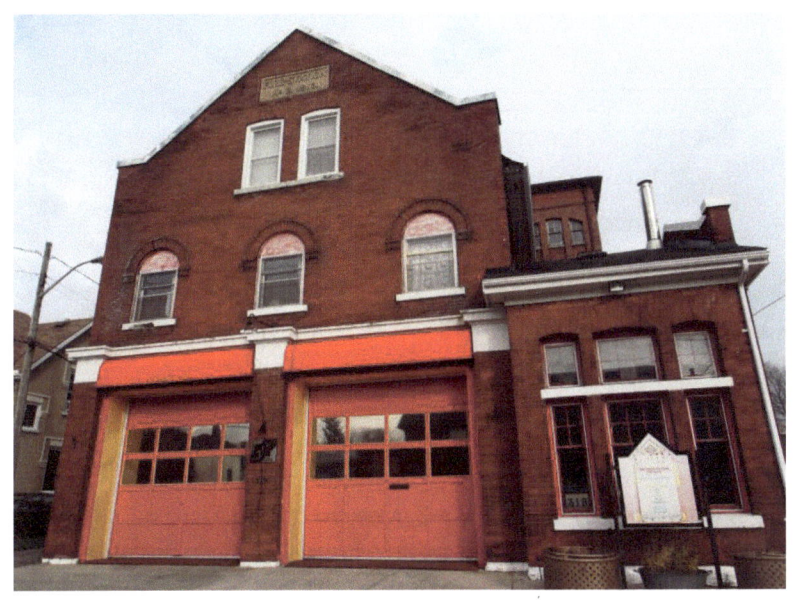

318 Breithaupt Street – Fire Station No. 2 - 1913

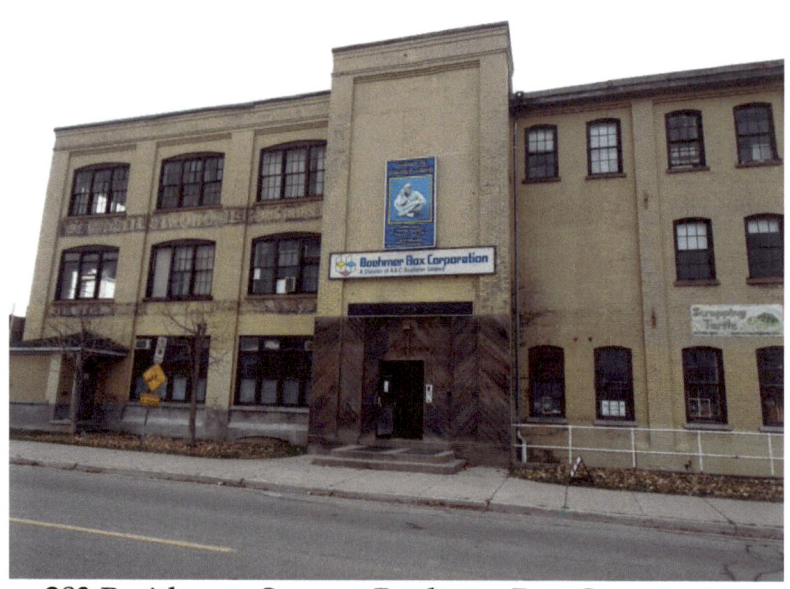

283 Breithaupt Street – Boehmer Box Corporation

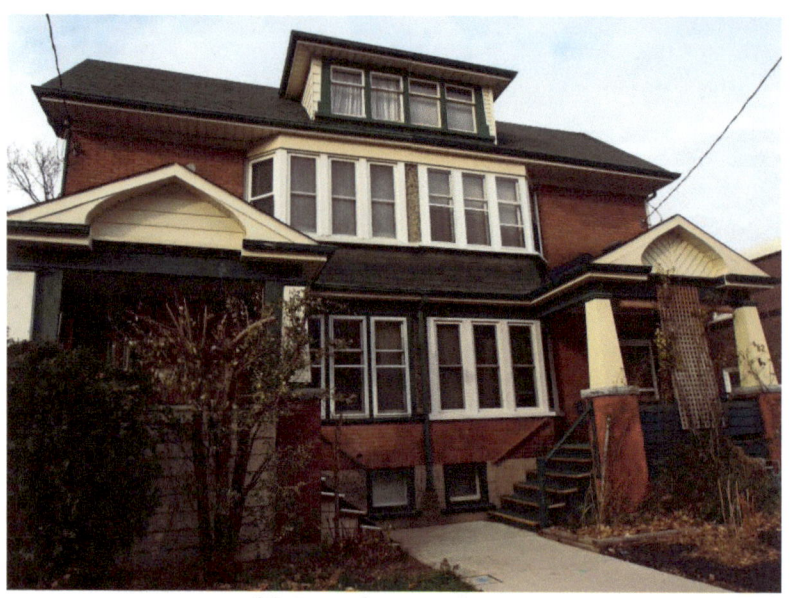

82 Breithaupt Street

57 Breithaupt Street – Gothic Revival

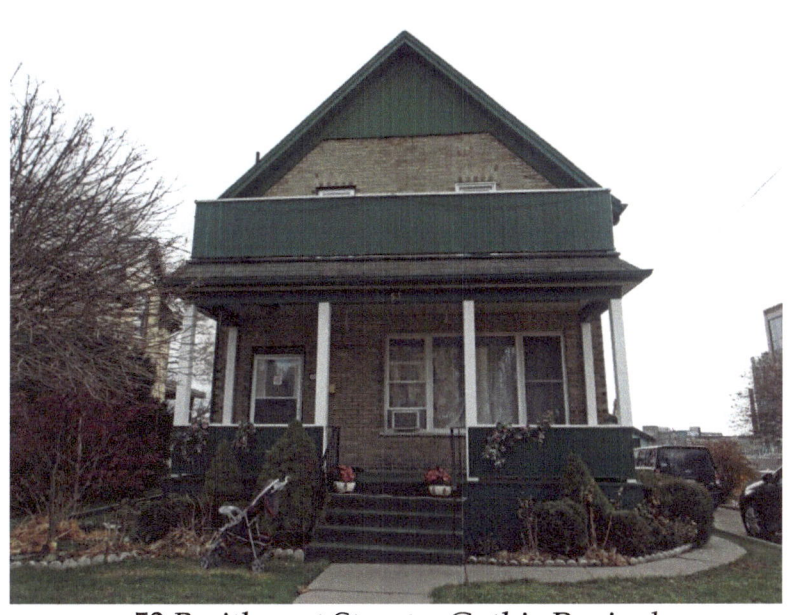

53 Breithaupt Street – Gothic Revival

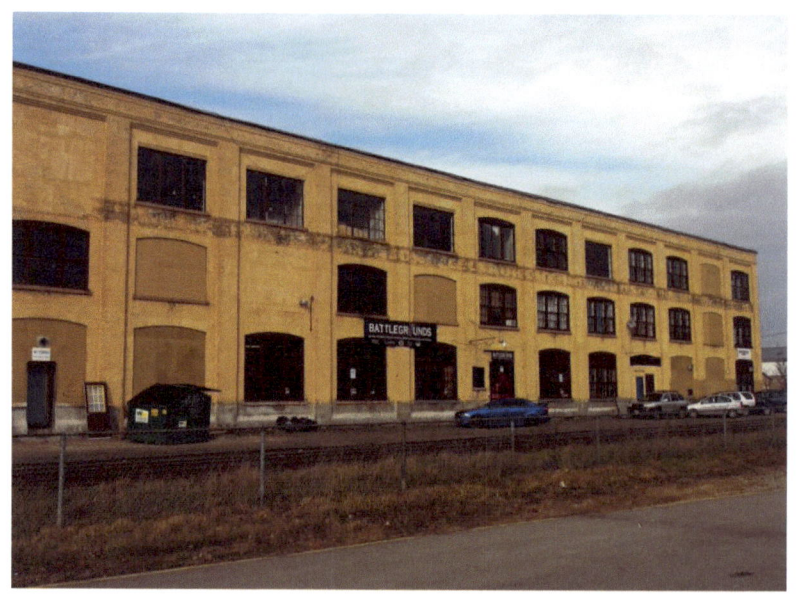

Breithaupt Block – originally rubber footwear factories

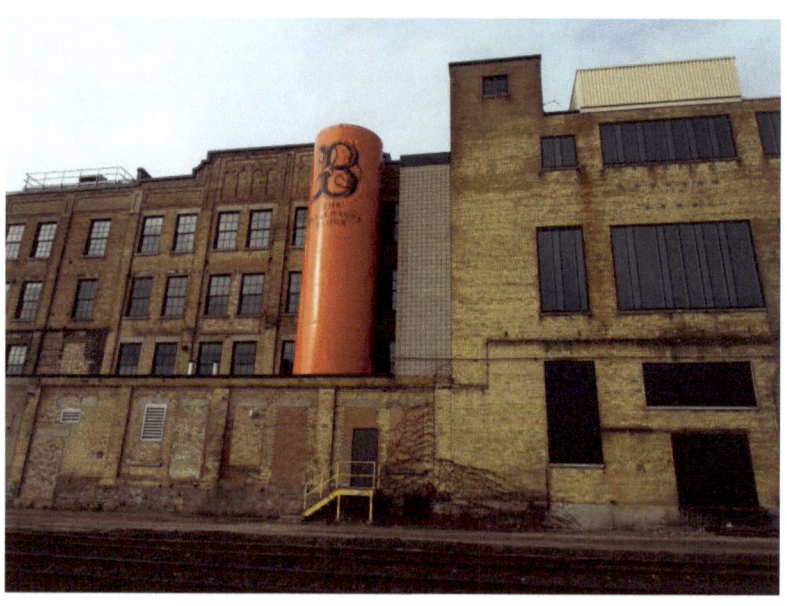

51 Breithaupt Street – adapted for office space

51 Breithaupt Street – built in 1903

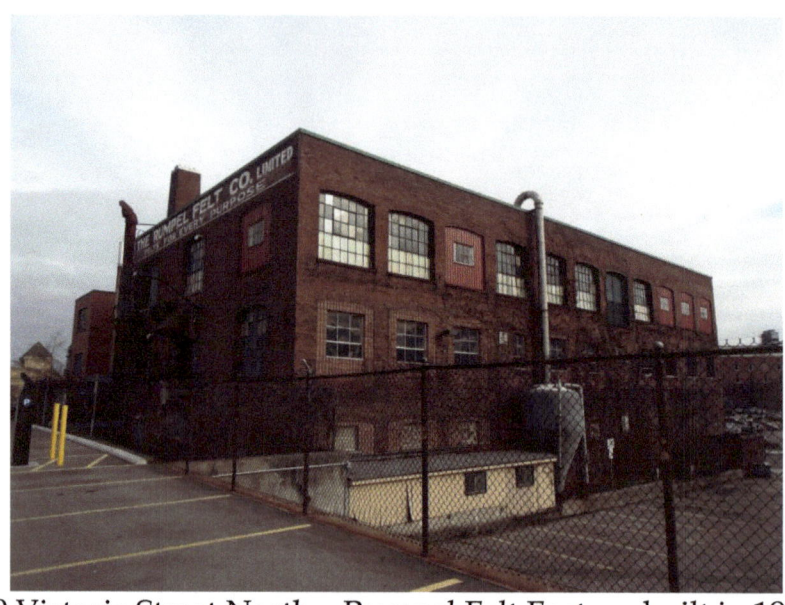

60 Victoria Street North – Rumpel Felt Factory built in 1913
- in operation from 1875 to 2008

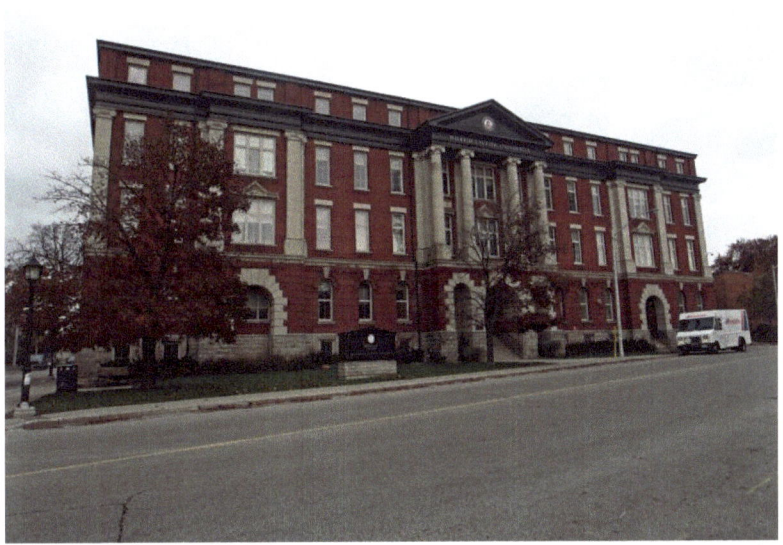

Wilfrid Laurier University building – Beaux Arts style

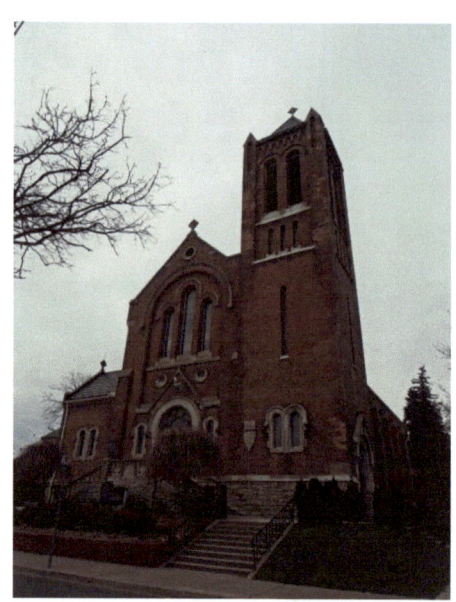

66 Shanley Street - Sacred Heart Roman Catholic Church

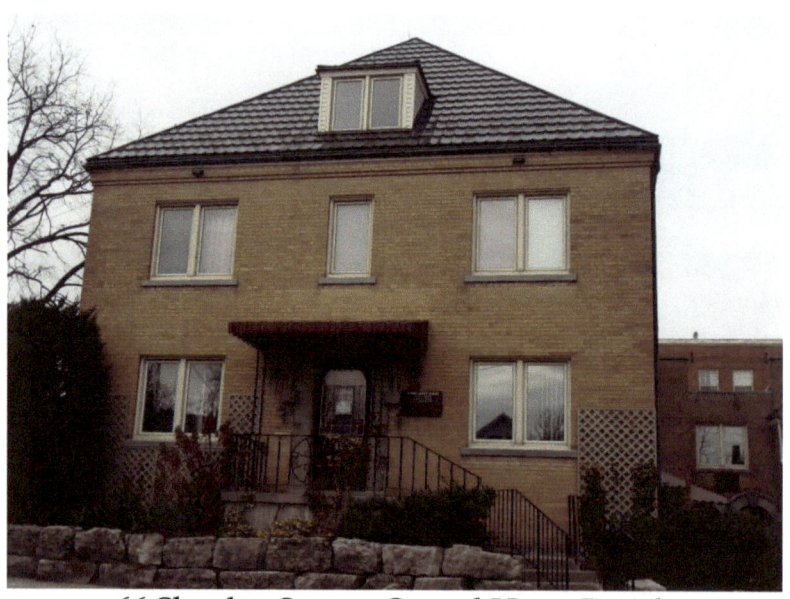

66 Shanley Street - Sacred Heart Parish

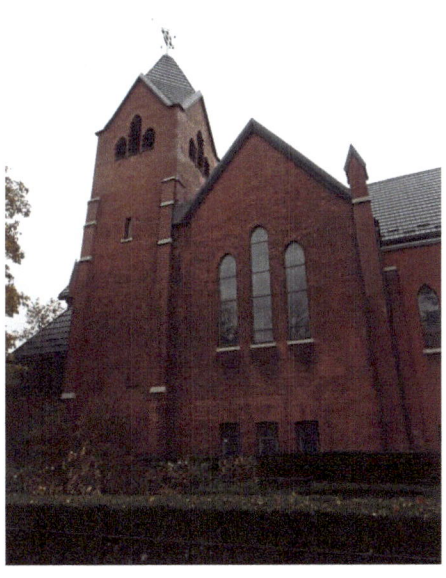

23 Water Street – The Anglican Church of St. John the Evangelist

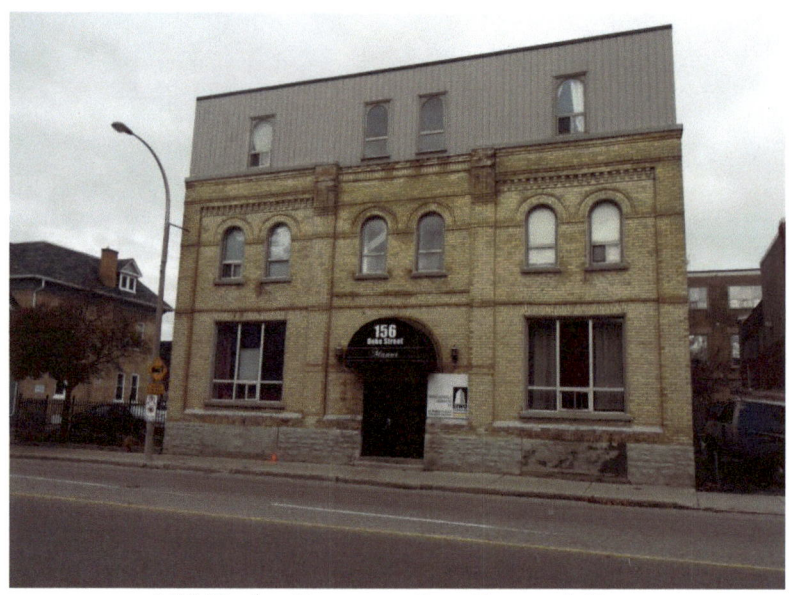
156 Duke Street – dentil moulding

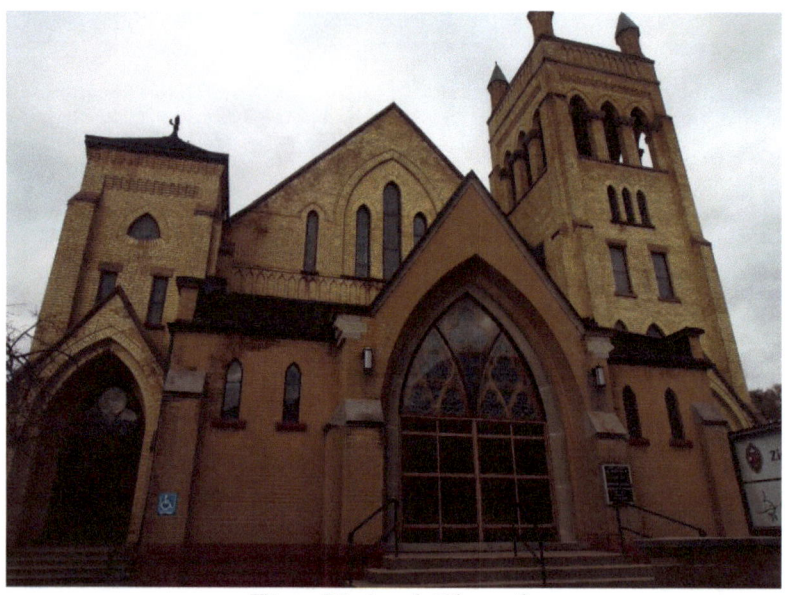
Zion United Church

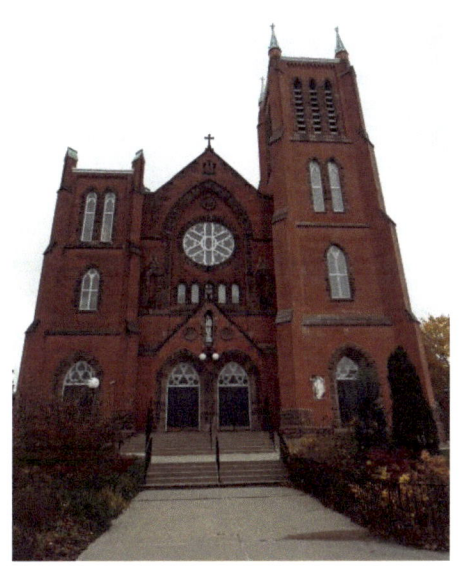

St. Mary's Roman Catholic Church

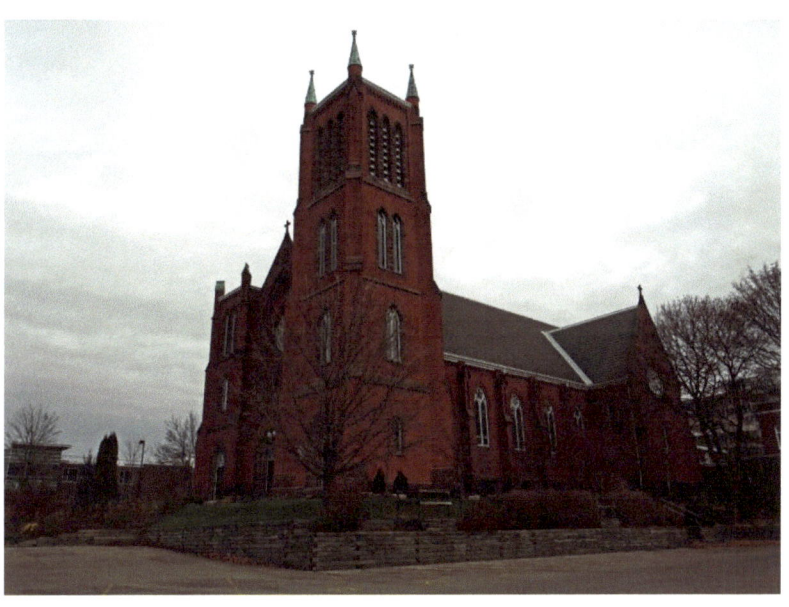

28 Weber Street West – Second Empire style – mansard roof, dormers in roof

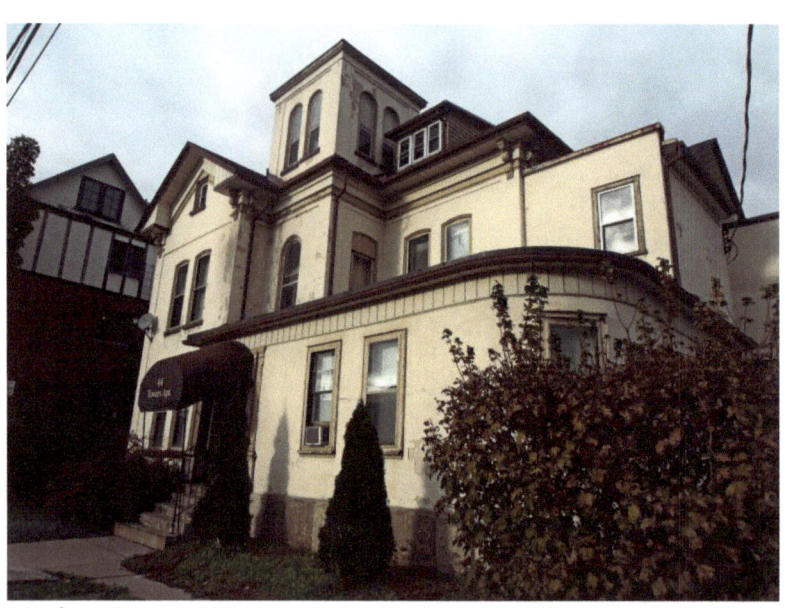

44 Weber Street West – Art Moderne with rounded corners, smooth walls, flat roofs

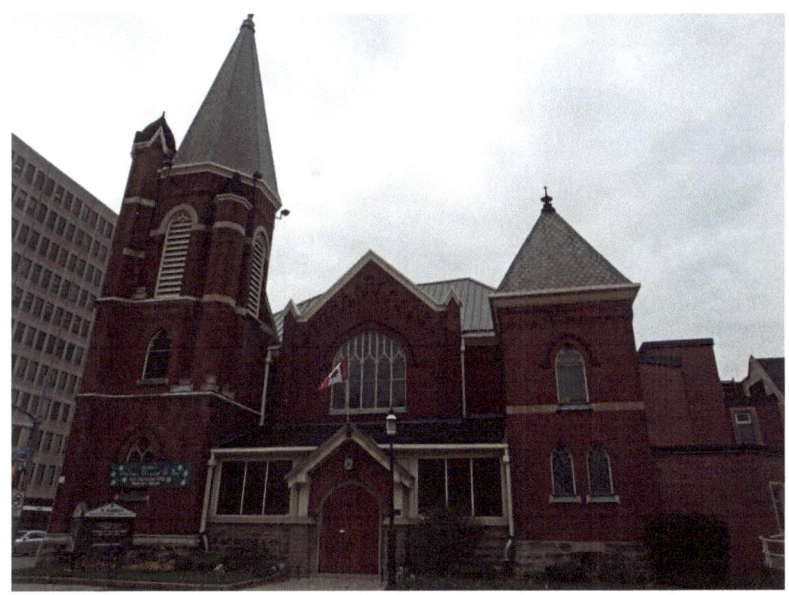

54 Queen Street North – St. Andrews Presbyterian Church

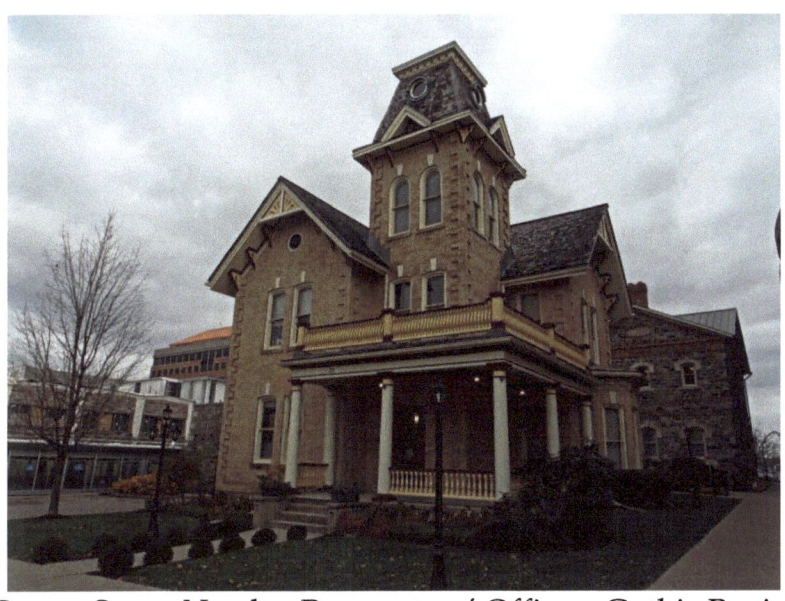

73 Queen Street North – Prosecutors' Office – Gothic Revival – decorative cornice brackets, arched window voussoirs with keystones, corner quoins

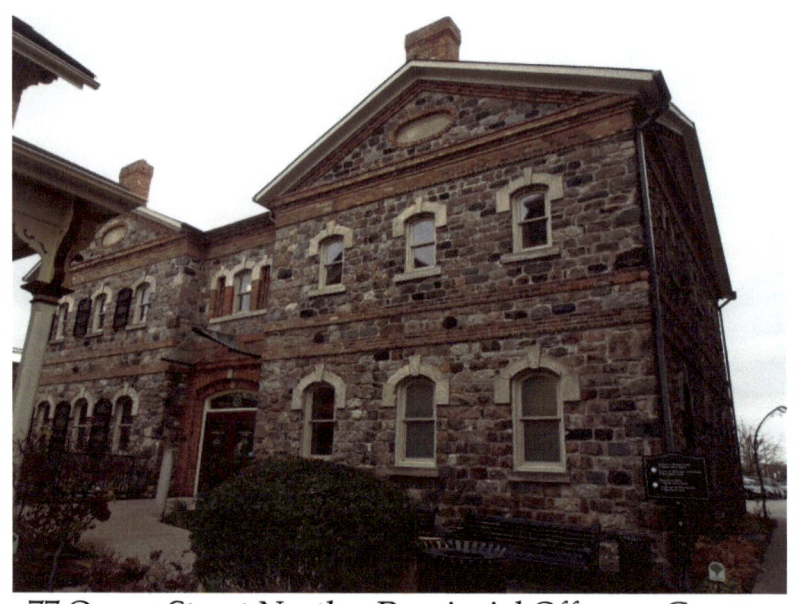

77 Queen Street North – Provincial Offences Court – cobblestone architecture, solid window hoods with keystones

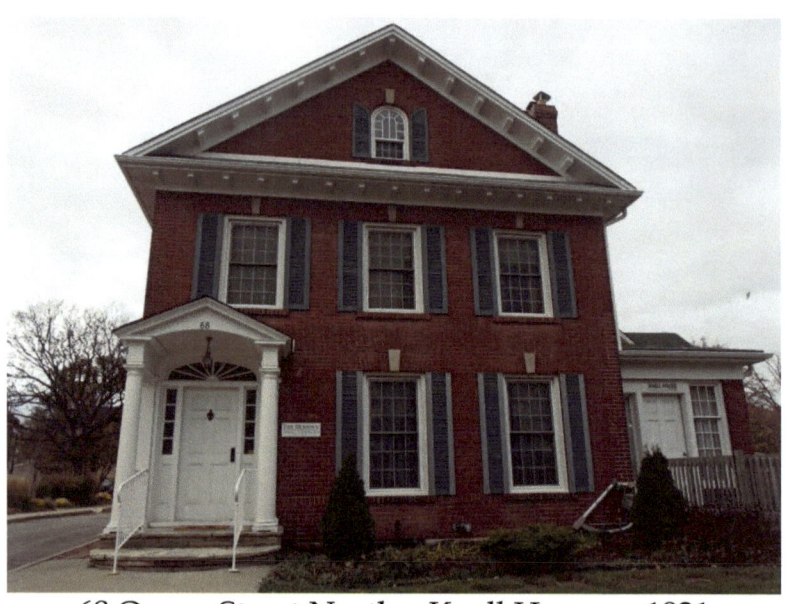

68 Queen Street North – Knell House c. 1921
Edwardian style

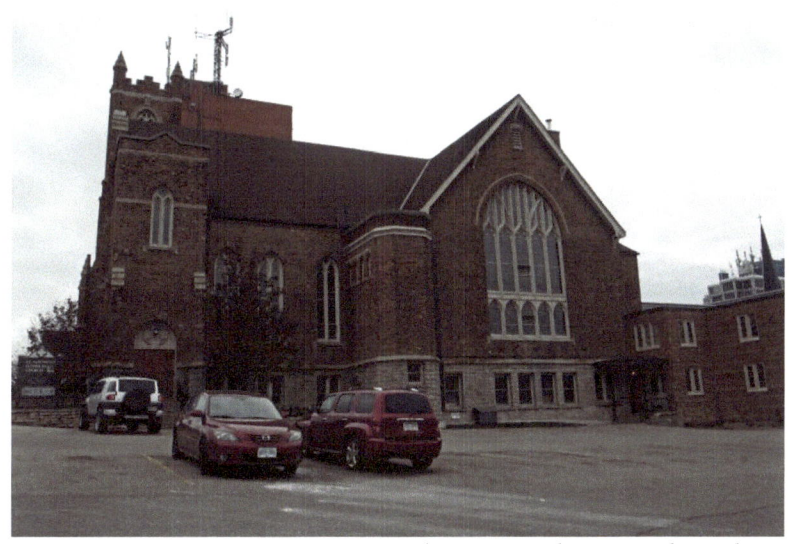

54 Benton Street – St. Matthews Lutheran Church

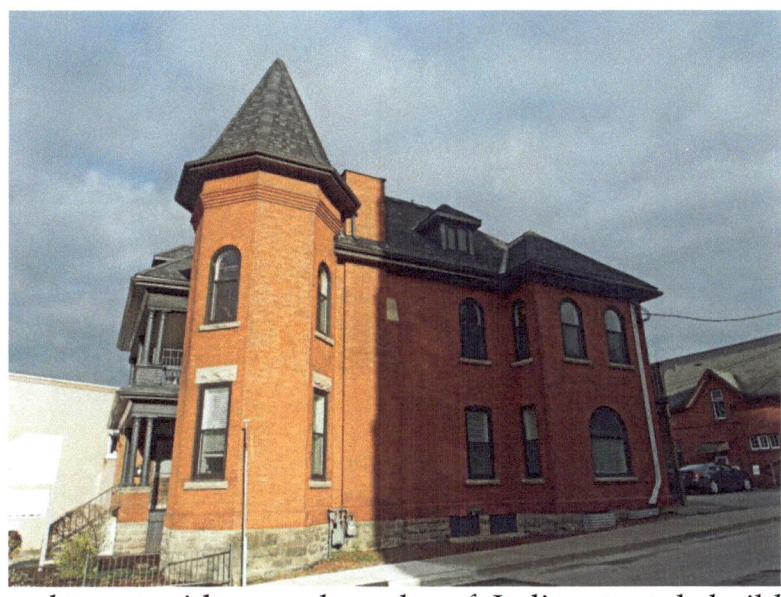

Round turret with cone-shaped roof, Italianate style building

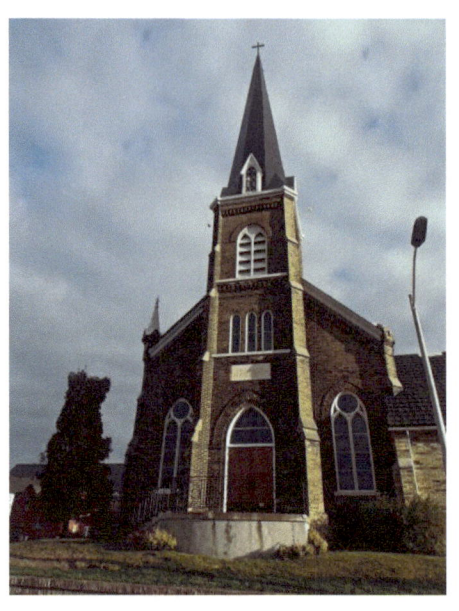

137 Queen Street South – St. Paul's Lutheran Church

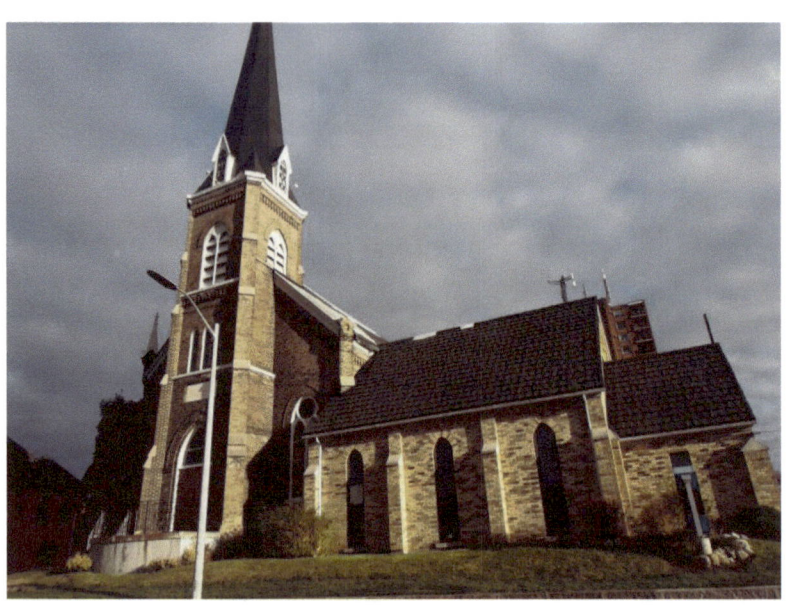

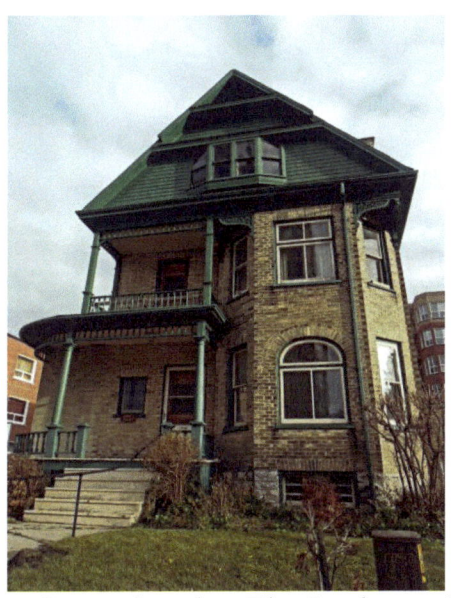

149 Queen Street South – The Lutheran Building

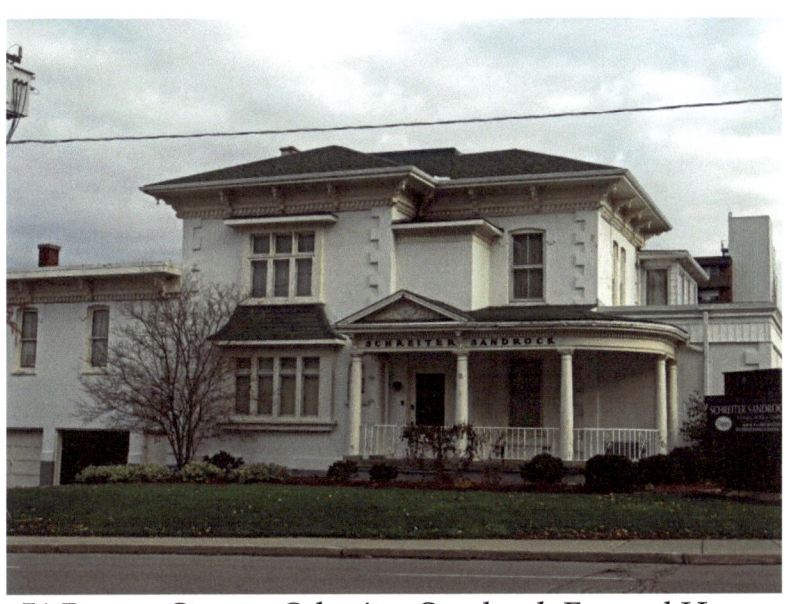

51 Benton Street – Schreiter Sandrock Funeral Home
Italianate style, cornice brackets, hipped roof, dentil moulding, corner quoins

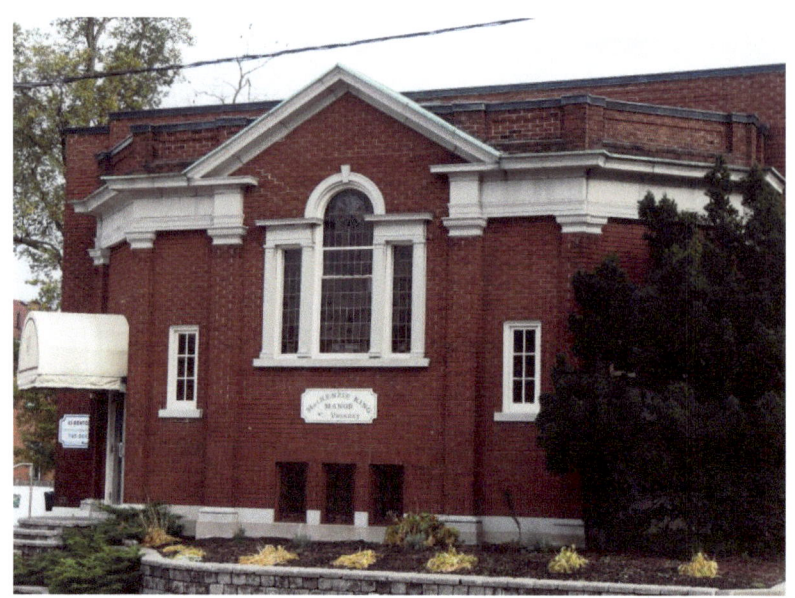
Benton Street – MacKenzie King Manor

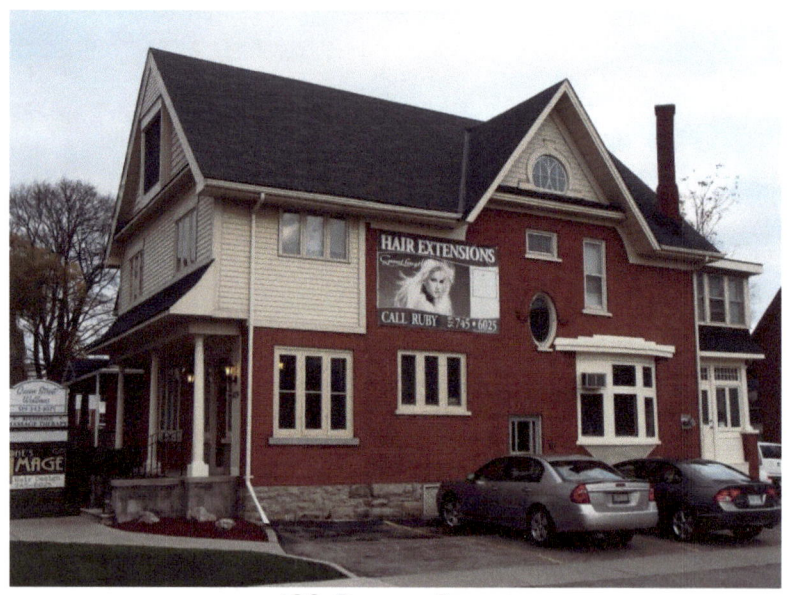
429 Queen Street

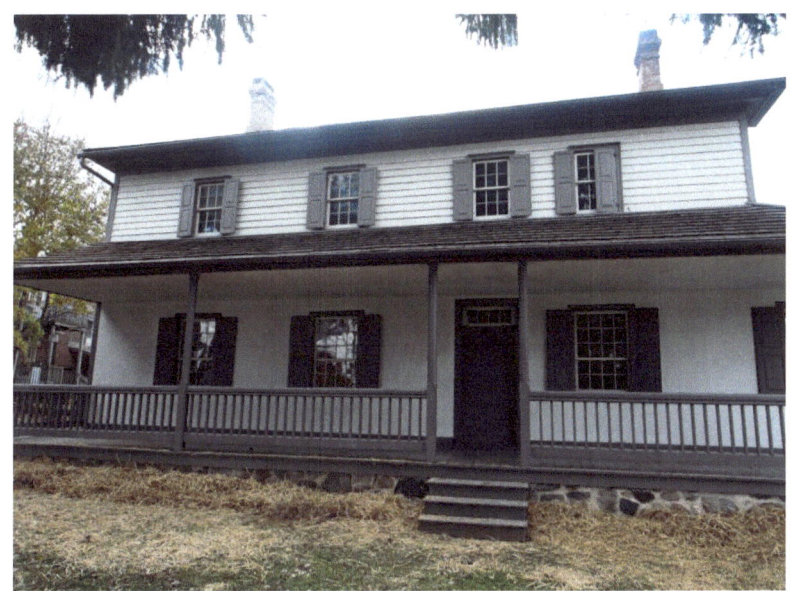

466 Queen Street South – Joseph Schneider Haus c. 1816 Georgian style - The house that Joseph built still stands beside the creek and the farm kitchen still hums with activity throughout the changing seasons. The house opened as a museum on June 30, 1981.

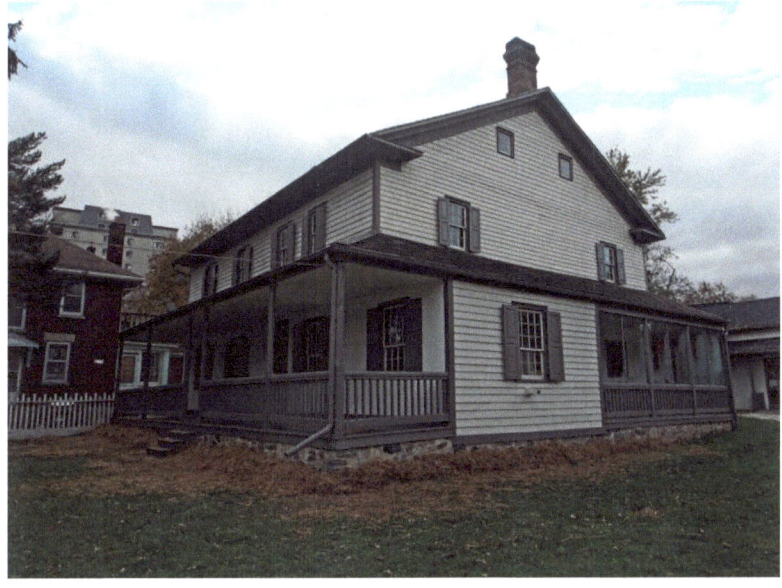

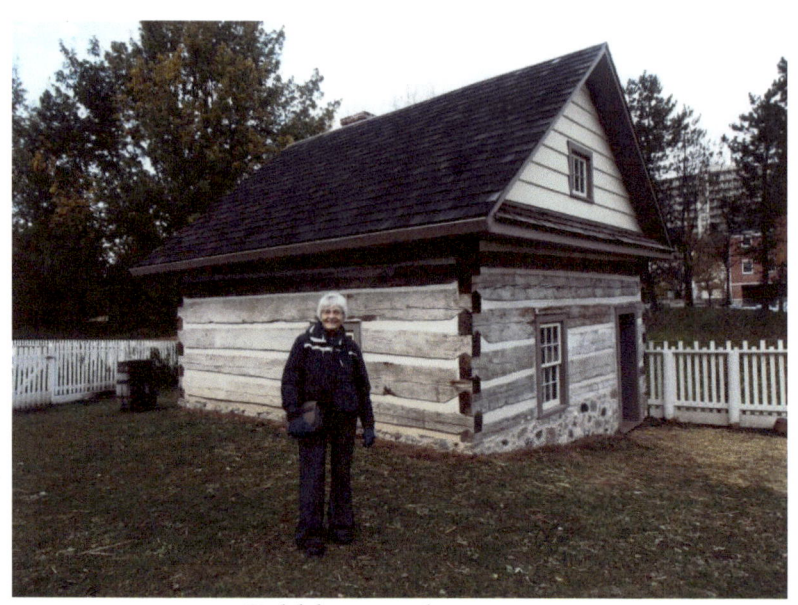

Cobblestone basement
Joseph Schneider Haus outbuildings

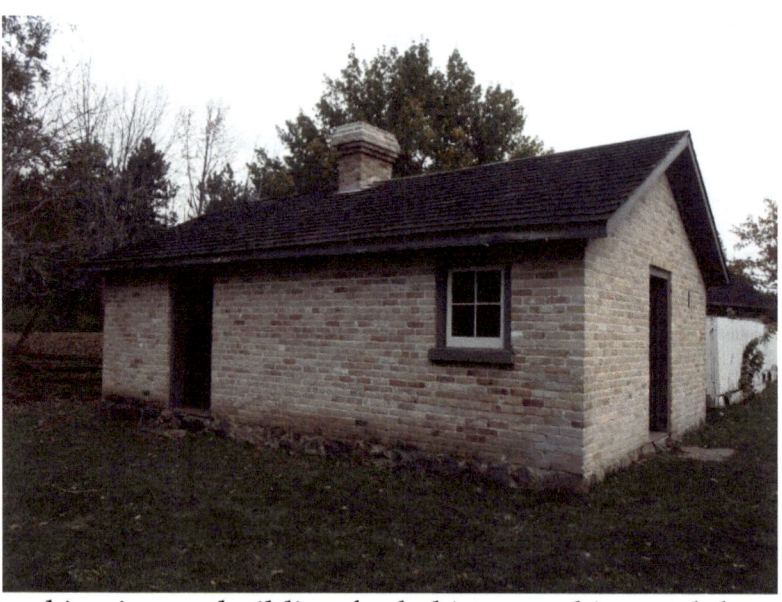

Combination outbuilding for baking, smoking and drying

24 Onward Avenue
Gothic Revival

44 Onward Avenue
Gothic Revival, cornice return

20 Onward Avenue – Gothic Revival
enclosed sunroom above verandah

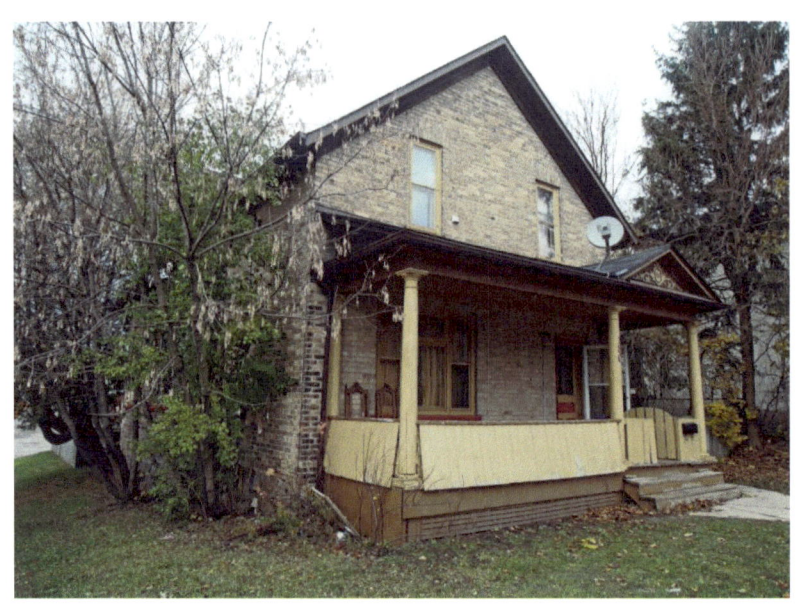

180 Onward Avenue – yellow brick – Gothic Revival, cobblestone basement

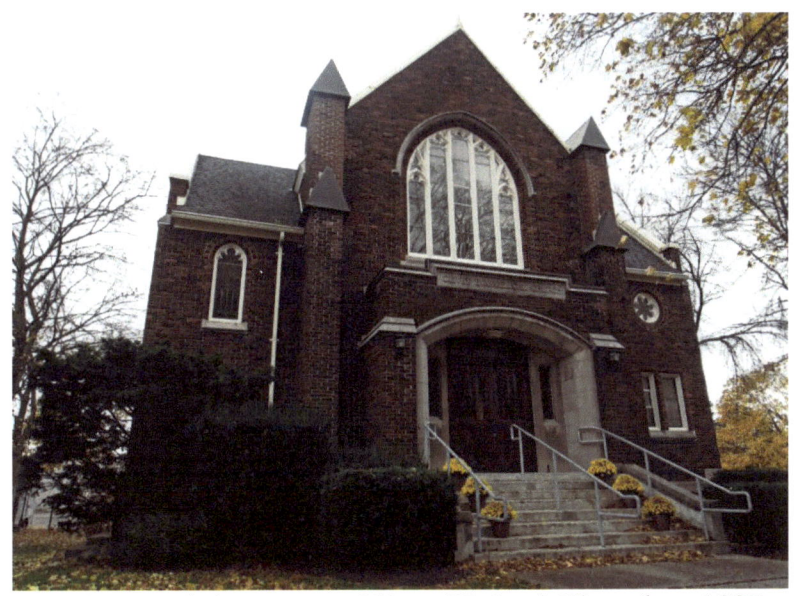

47 Onward Avenue – Olivet United Church c. 1935

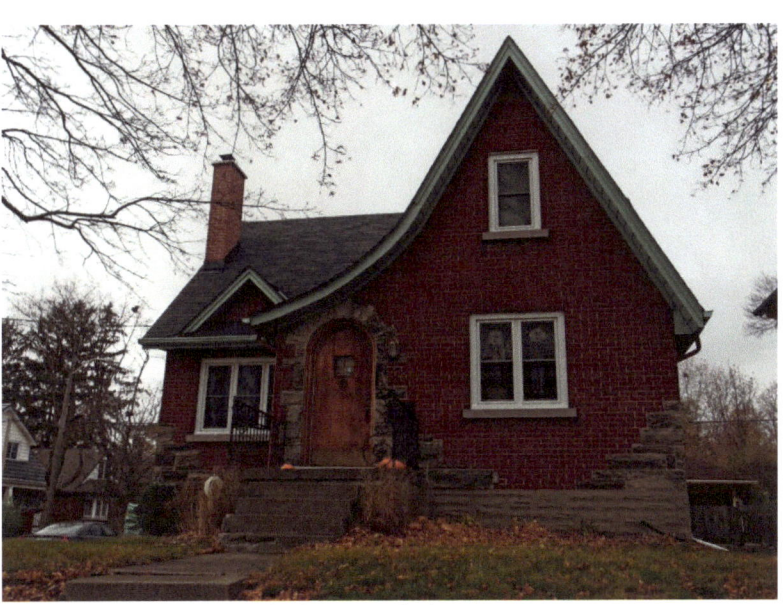

40 Onward Avenue

228 Pandora Crescent – Georgian style with dormer in attic

222 Pandora Crescent – Tudor style

216 Pandora Crescent – Gothic Revival – red brick

210 Pandora Crescent – Georgian style

199 Pandora Crescent – Georgian style – hip roof

205 Pandora Crescent – Georgian style

209 Pandora Crescent – Georgian style

221 Pandora Crescent – Georgian style

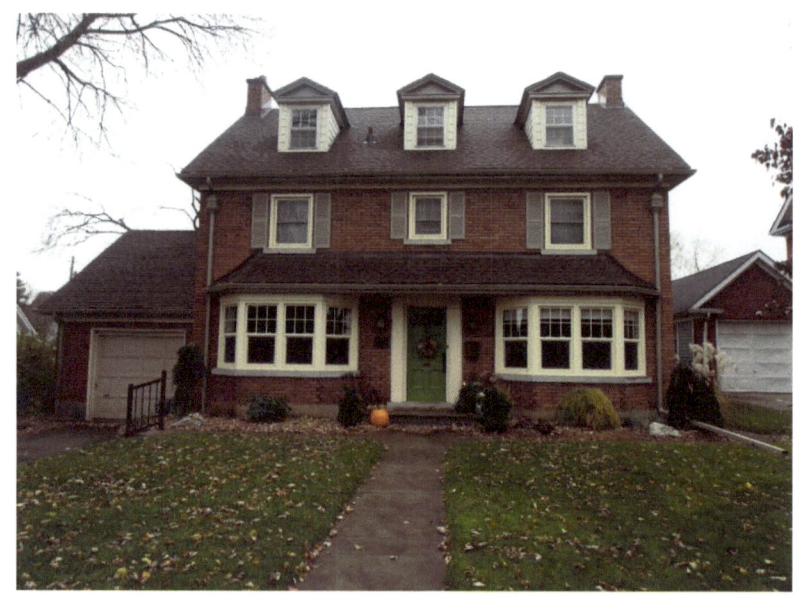

227 Pandora Crescent – Italianate style with dormers in attic

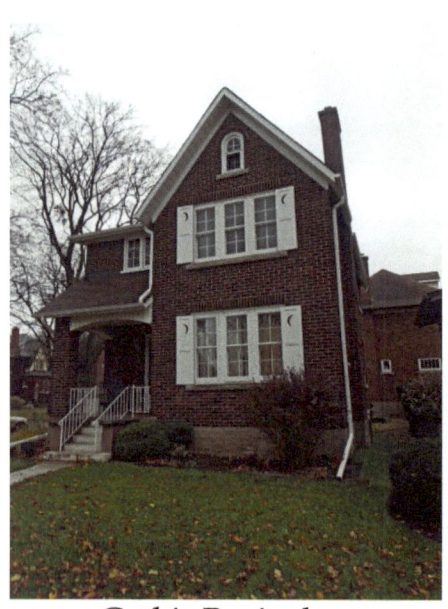

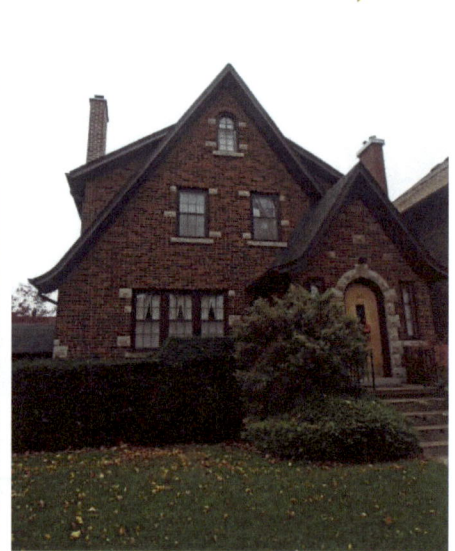

Gothic Revival

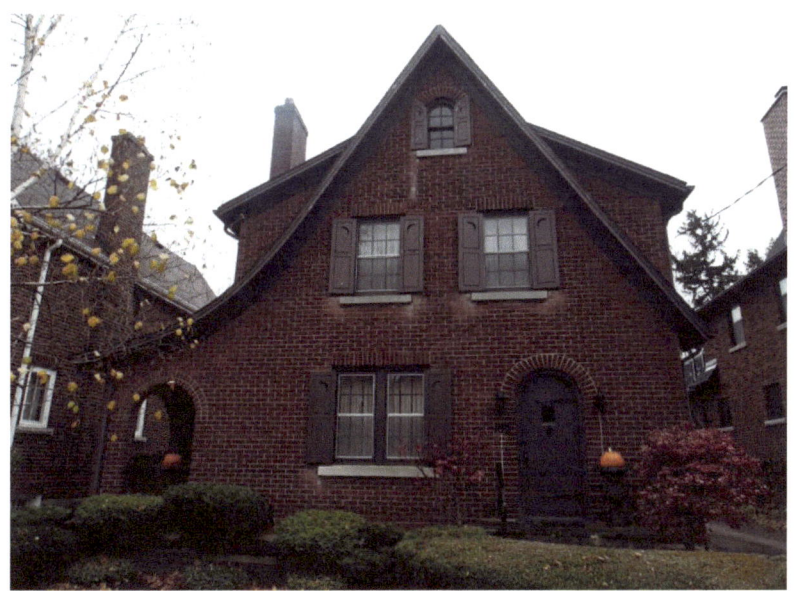

#169

81 Troy Street

800 King Street East – First Mennonite Church

Bishop Benjamin Eby came from Lancaster County, Pennsylvania to Upper Canada in 1806 and purchased extensive land in this vicinity on which he settled the following year. He was ordained a minister of the Mennonite Church in 1809 and was made a bishop in 1812. The first Mennonite Church in western Upper Canada was built in this settlement in 1813. The community was first known as Ebytown, then Berlin, and renamed Kitchener in 1916.

Window voussoirs, cornice brackets, cornice return on gable

In the process of restoration

Downtown

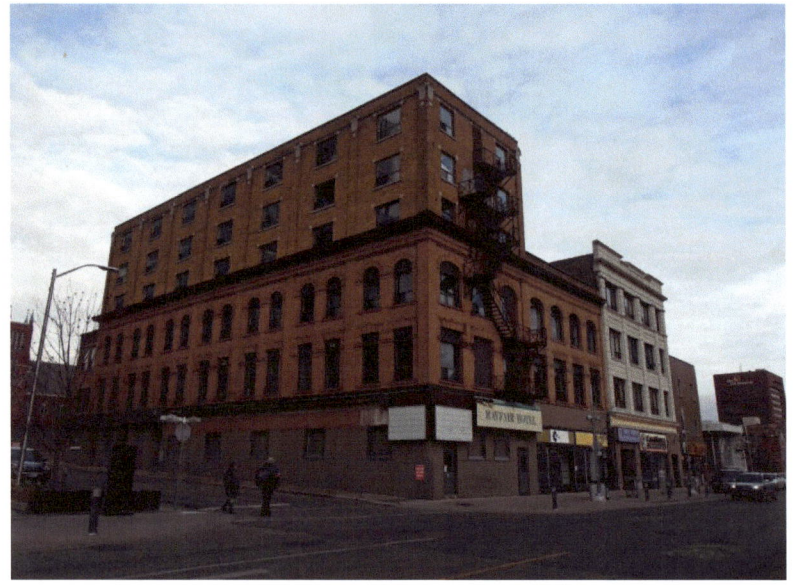

Mayfair Hotel – corner of King and Young

Dentil moulding

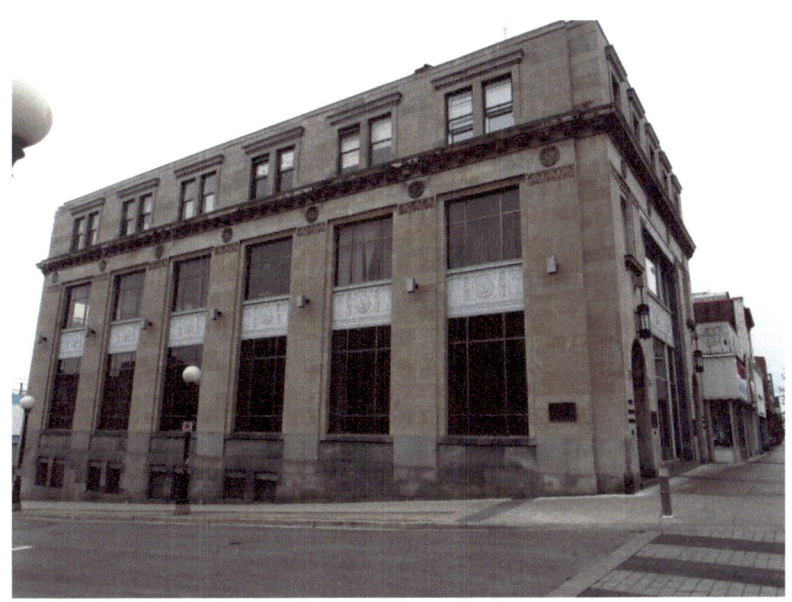

Public Utilities Building

Decorative brickwork

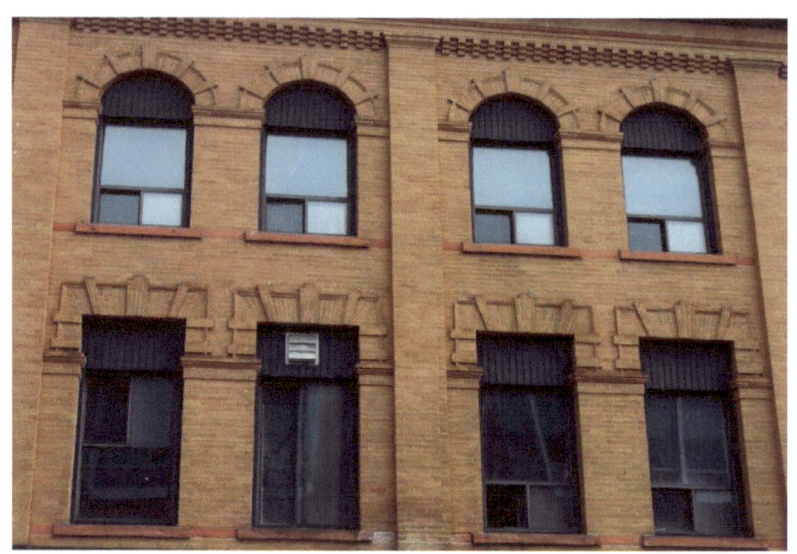
Decorative window hoods and keystones

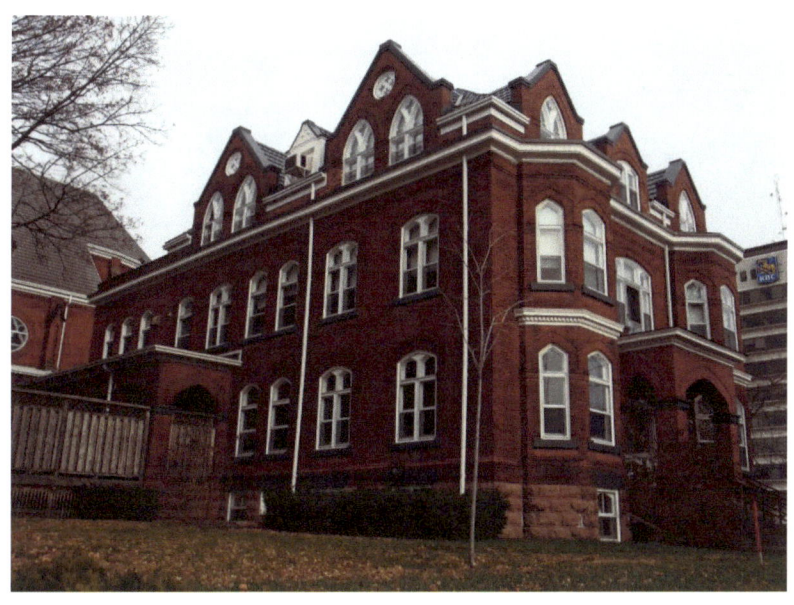

#56

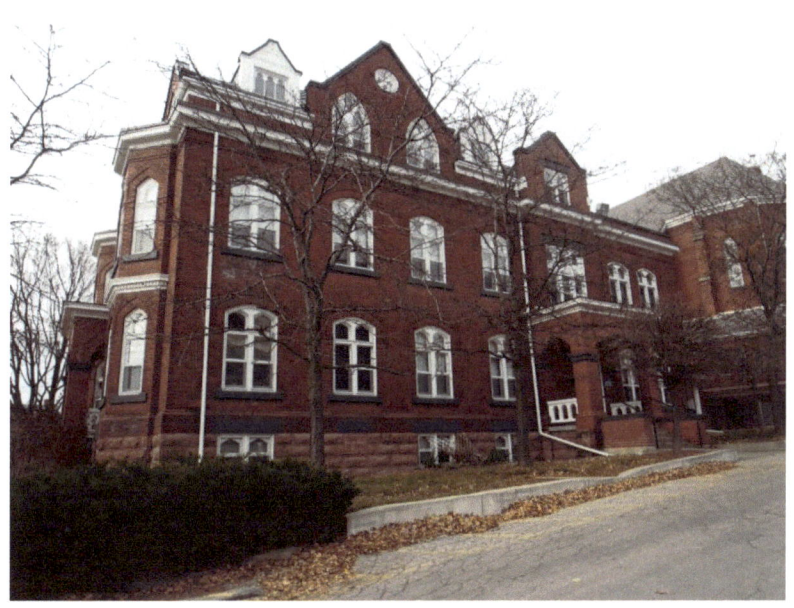

c. 1895

Arched voussoirs with keystones, dentil moulding

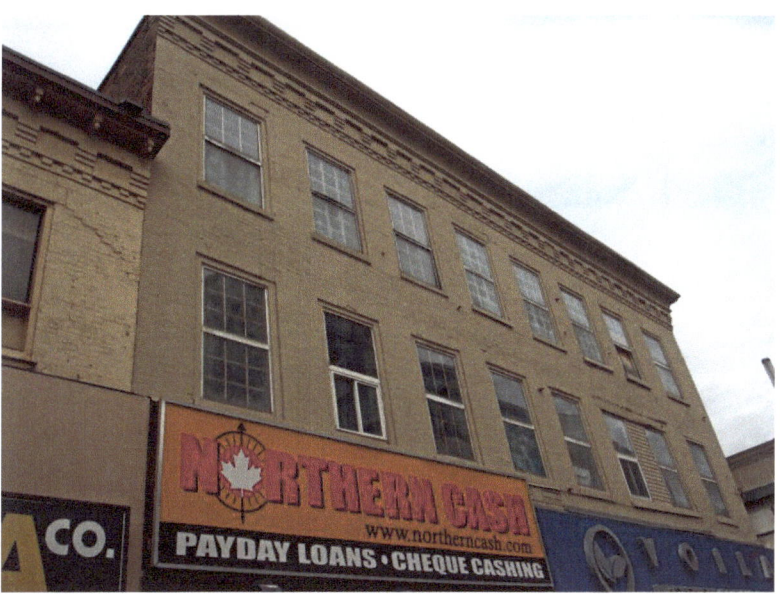

More modern building

Pillars with capitals, dentil moulding

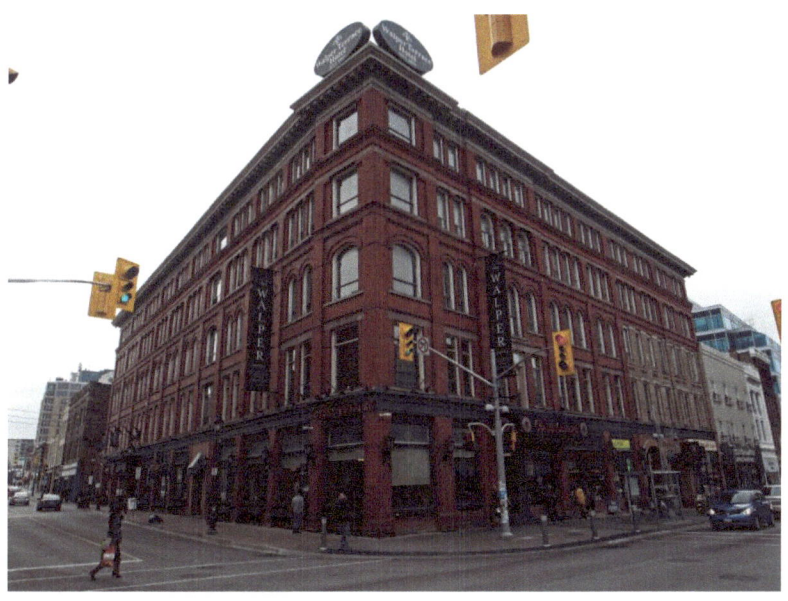

Walper Hotel established 1893 – where Eleanor Roosevelt enjoyed breakfast in the courtyard and Louis Armstrong played his trumpet off the King Street balcony

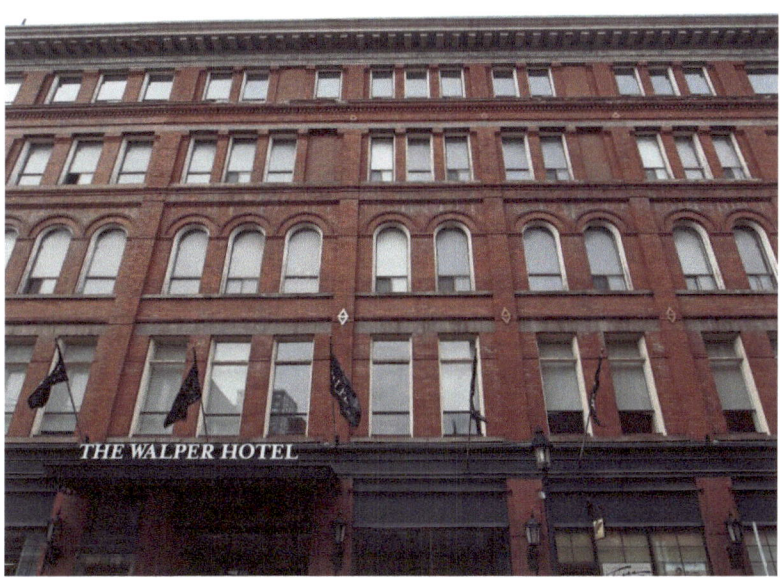

Cornice brackets, dentil moulding, decorative window hoods and keystones

Dentil moulding, pilasters, decorative brickwork

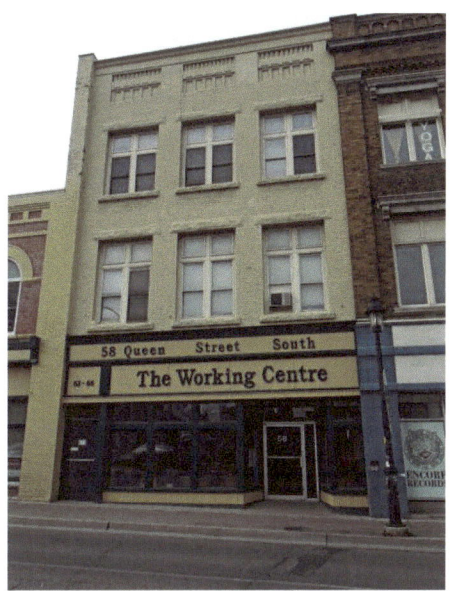

58 Queen Street South

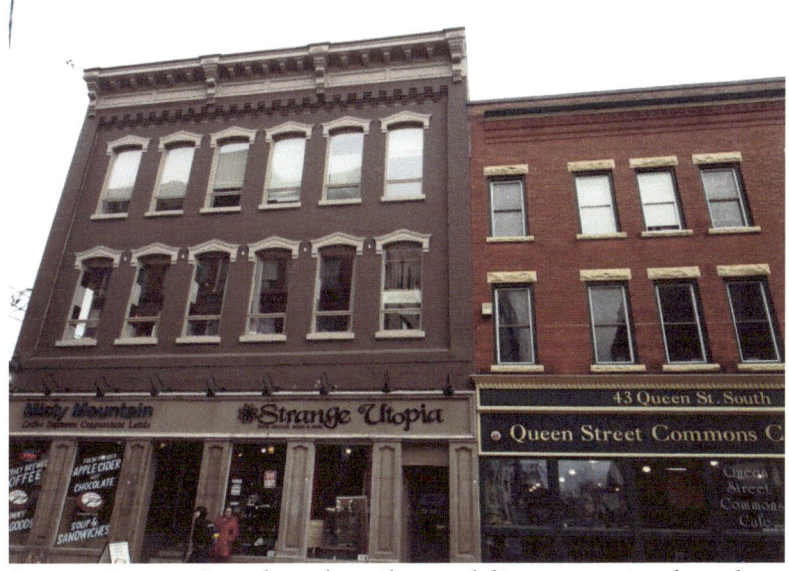

Queen Street South – dentil moulding, cornice brackets

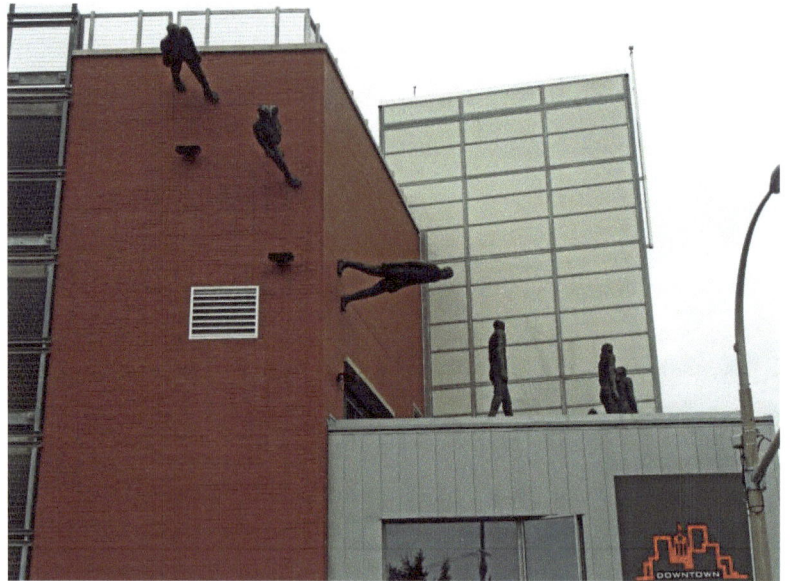

Interesting with figures walking down the walls and across the rooftop

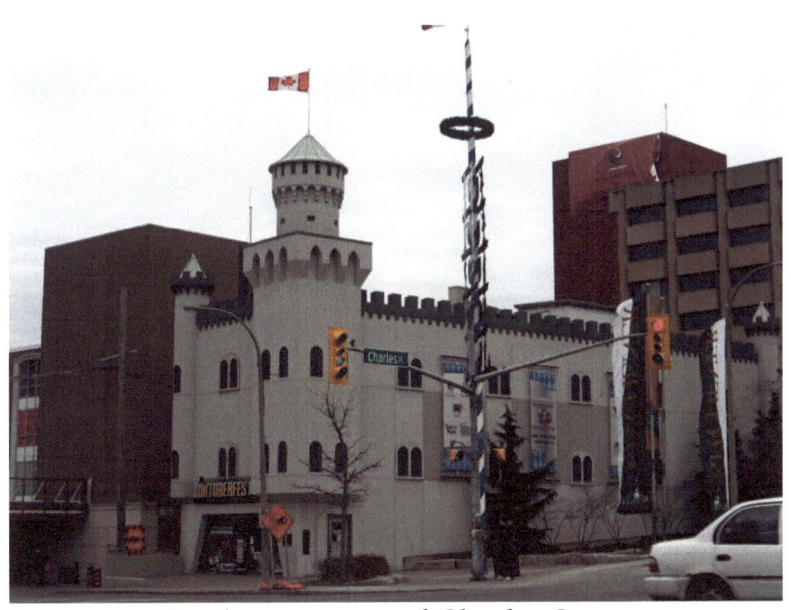
Castle on corner of Charles Street

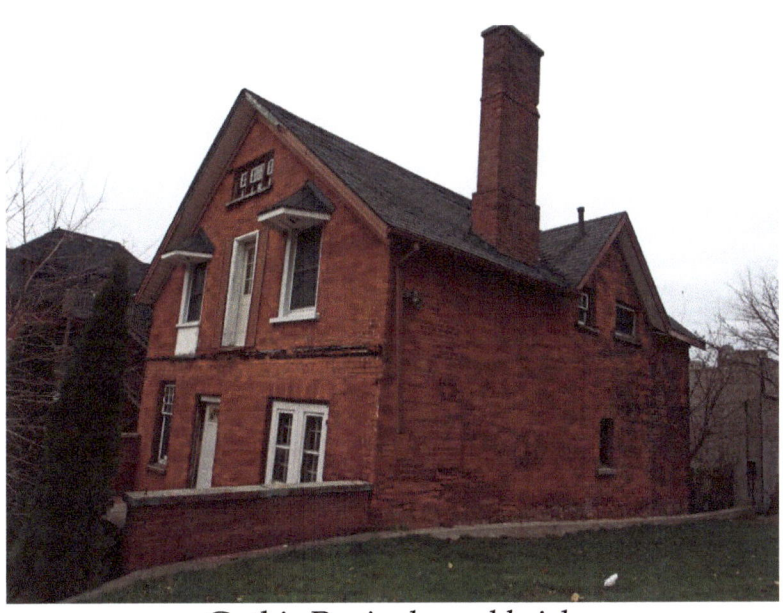
Gothic Revival – red brick

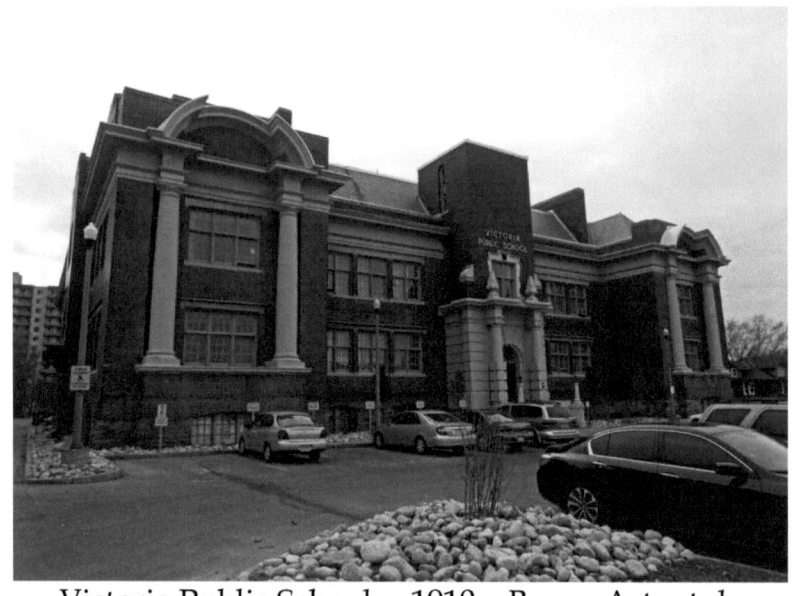

Victoria Public School c. 1910 – Beaux Arts style
25 Joseph Street

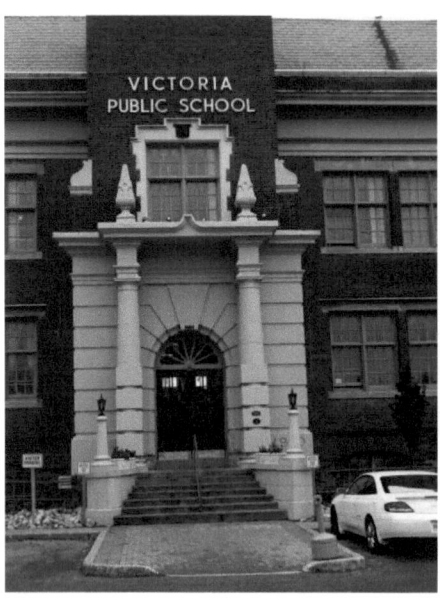
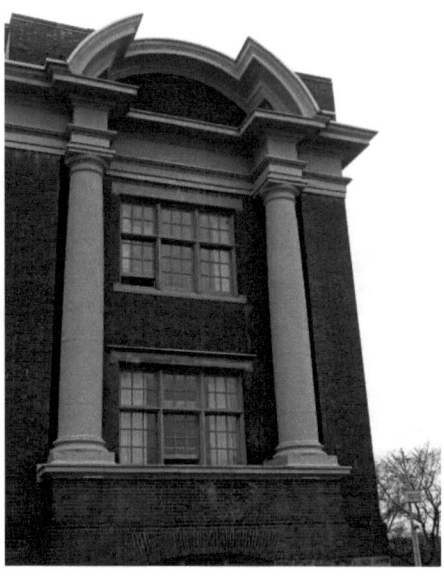

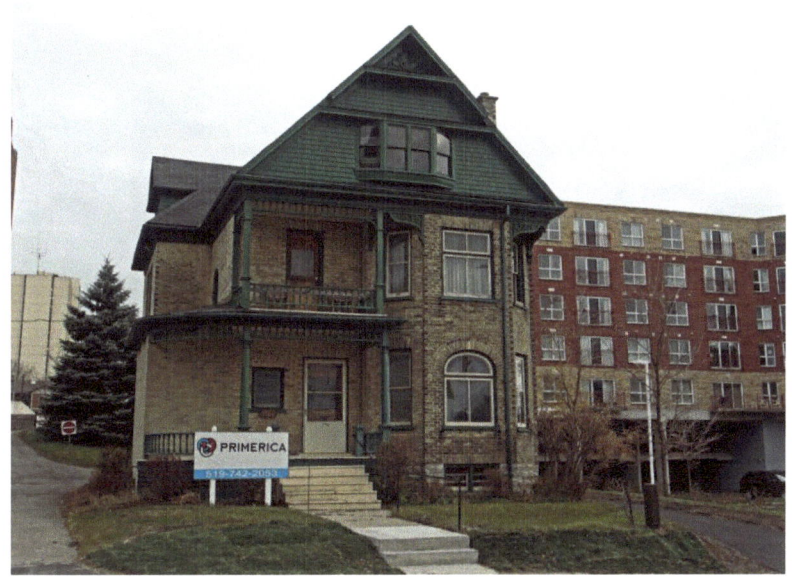

Yellow brick – Edwardian style

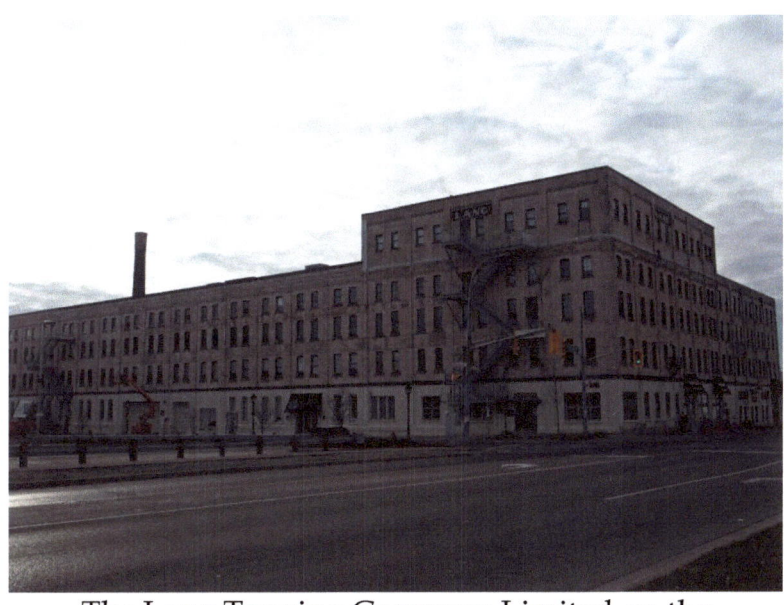

The Lang Tanning Company Limited on the corner of Charles Street

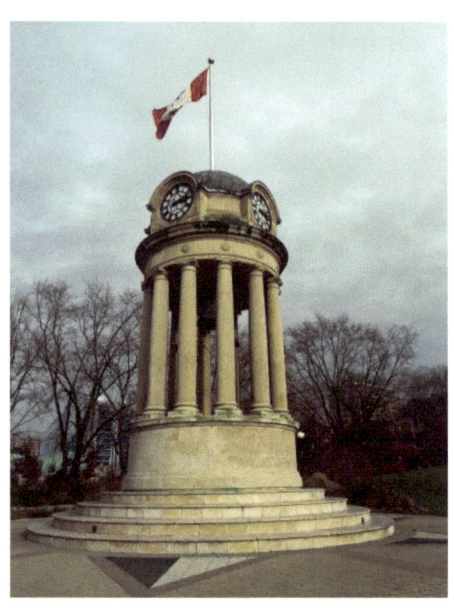

The clock tower was built in 1924 and adorned the Kitchener City Hall for 48 years. It was dismantled in 1973, restored and placed in Victoria Park in 1995.

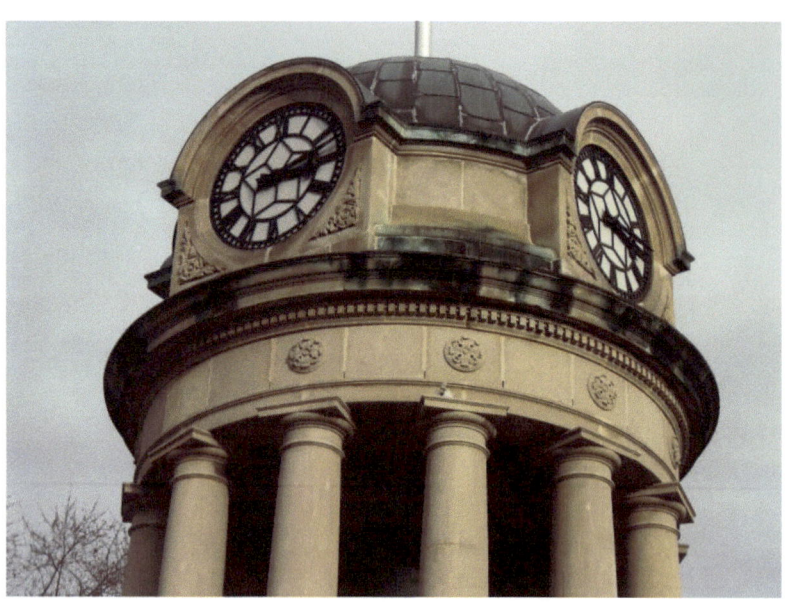

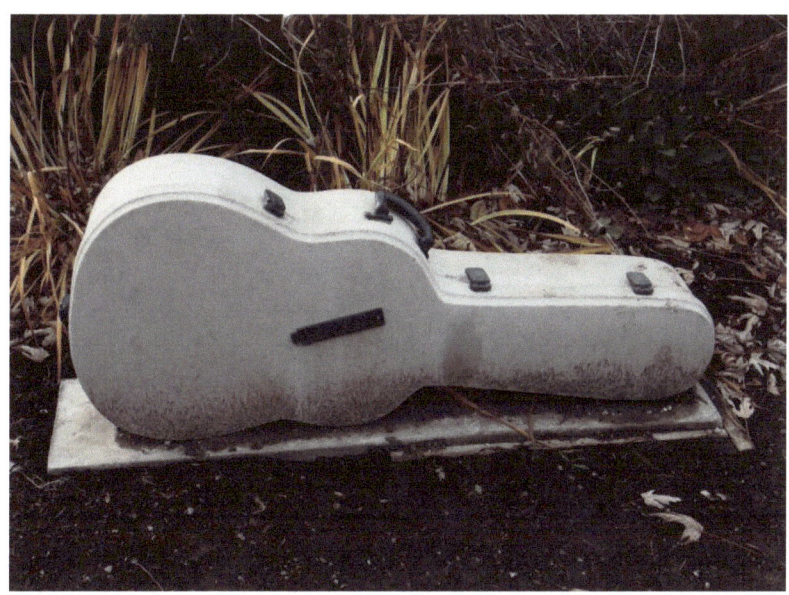

The Luggage Project – Limestone and Bronze – Ernest Daetwyler (2006) – three of the eight carved sculptures modelled after life-size luggage pieces from various time periods in tribute to thousands of migrants

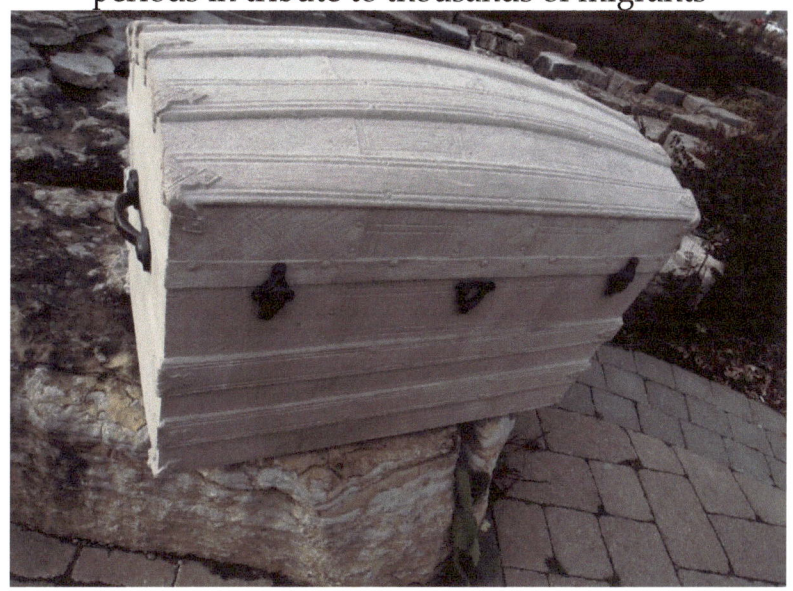

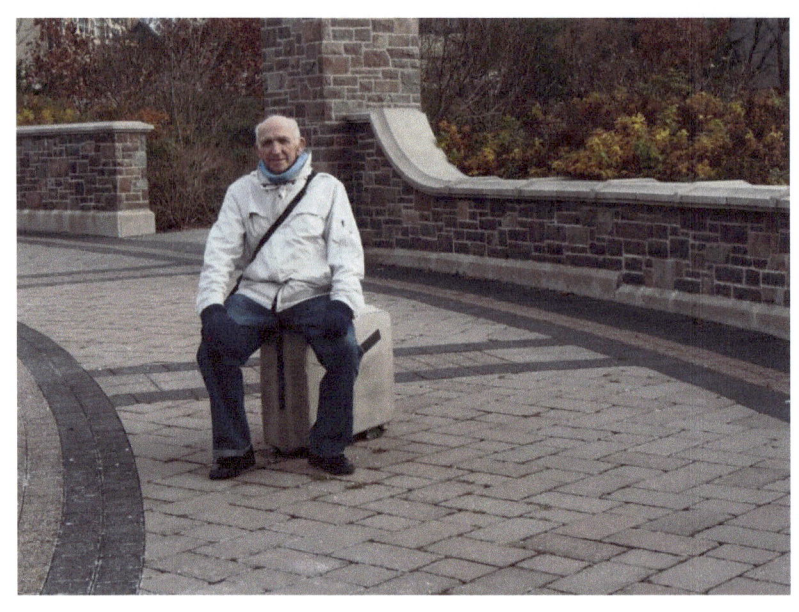

"Ready for our trip"

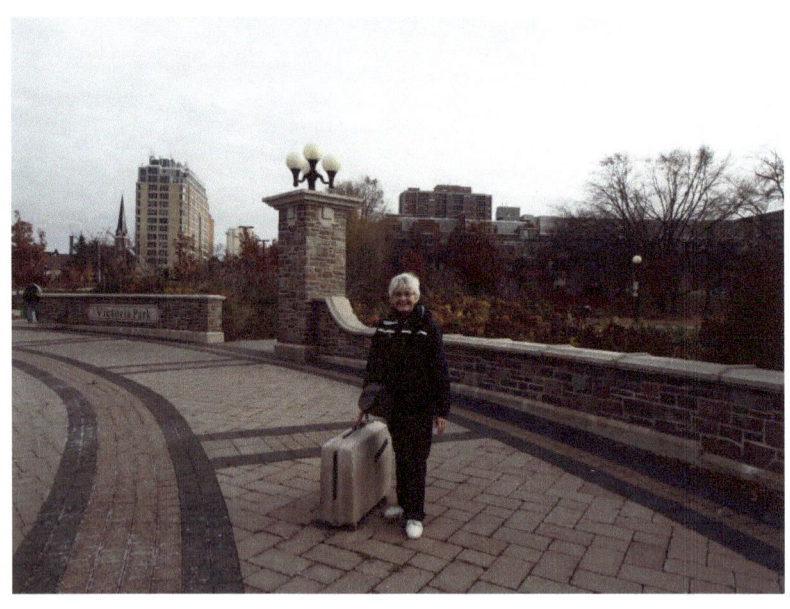

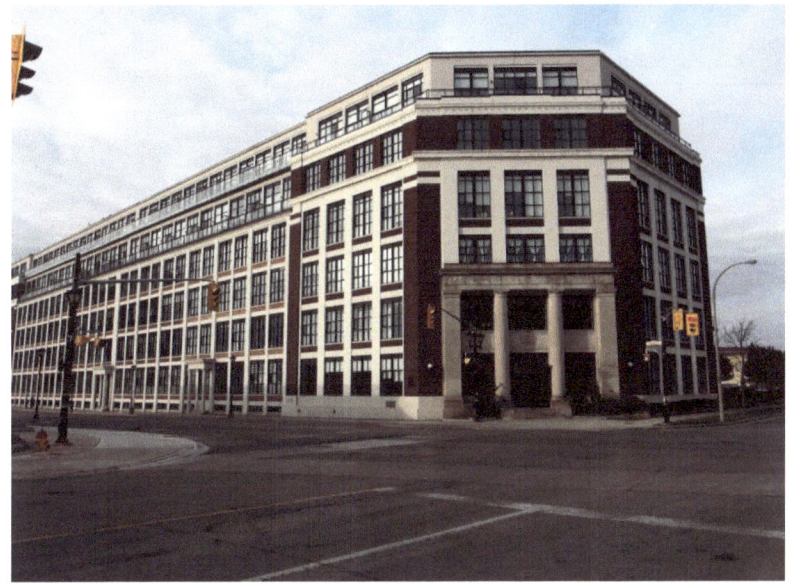

Kaufman Rubber Company

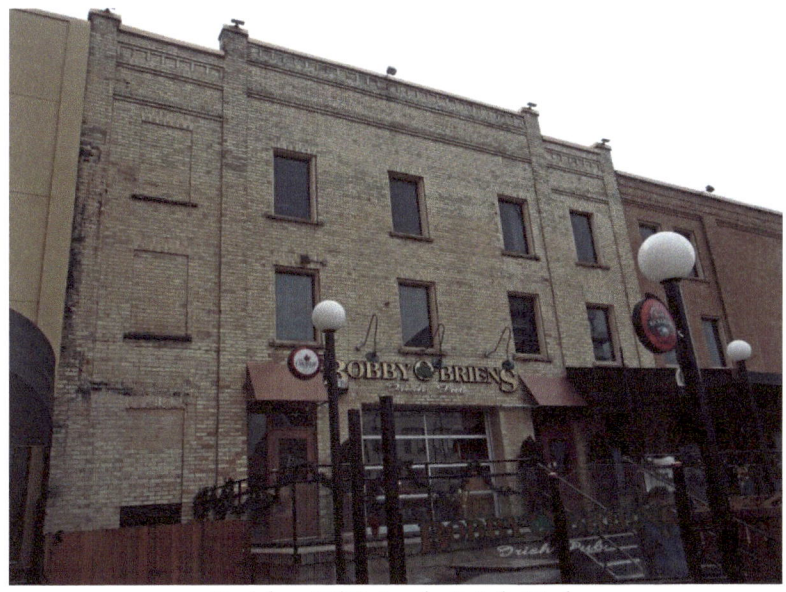

Bobby O'Brien's Irish Pub

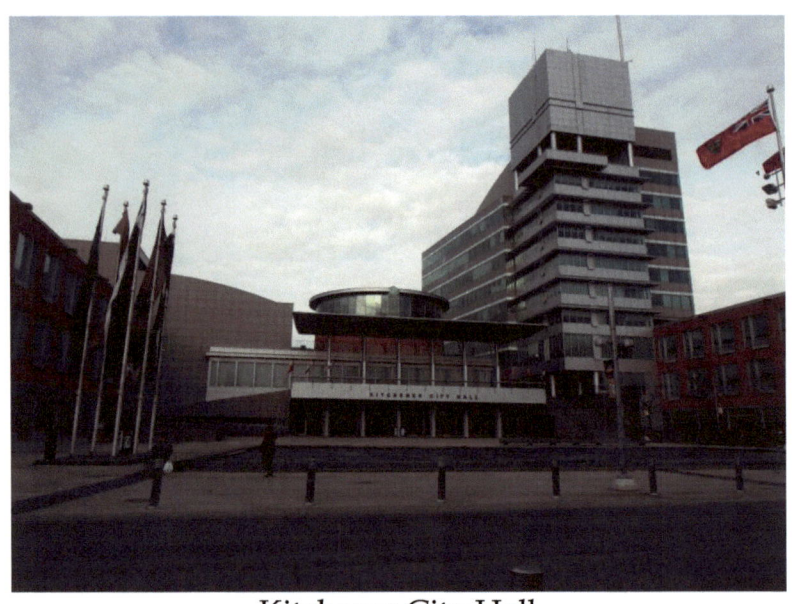

Kitchener City Hall

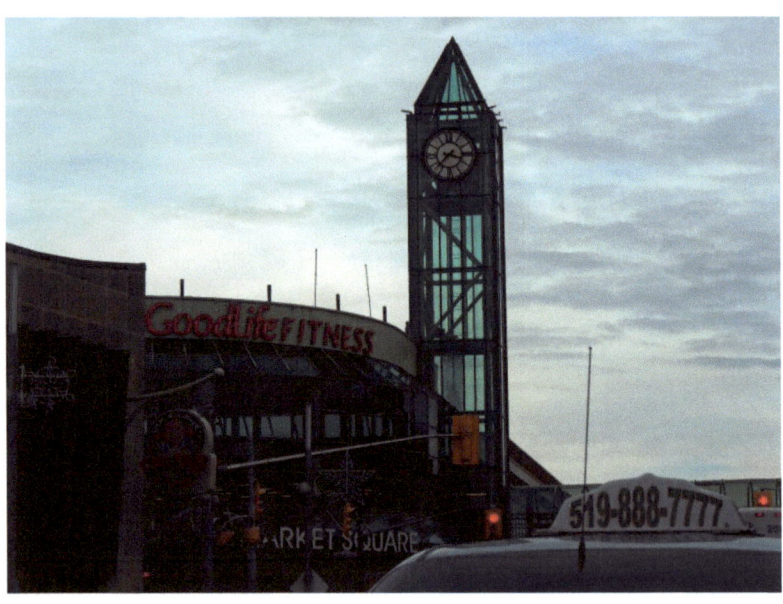

Architectural Terms

Brackets: a decorative or weight-bearing structural element which forms a right angle with one side against a wall and the other under a projecting surface such as an eave or roof. Example: 208 Ahrens Street	
Cobblestone architecture: Refers to the use of cobblestones embedded in mortar as a method for erecting walls on houses and commercial buildings. Example: 77 Queen Street North, Provincial Offences Court	
Cornice: originally the wooden overhang of the roof. With the use of stone, brick, iron and steel, the cornice is any projecting shelf at the top of a ceiling or roof. They can be very decorative. Example: Via Train Station	
Cornice Return: decorative element on the end of a gable. Example: 44 Onward Avenue	
Dentil Moulding: an even series of rectangles used as ornamental decoration in cornices. Examples: Via Rail Train Station and 156 Duke Street	
Dormer: (French for "sleep") a gable end window that pierces through the plane of a sloping roof surface to create usable space in the top floor or attic of a building by adding headroom. Example: 227 Pandora Crescent	

Gable: the triangular portion of a wall between the edges of a sloping roof. Example: 466 Queen Street South, Joseph Schneider Haus	
Hipped Roof: a roof where all sides slope downwards to the walls with no gables. Example: 199 Pandora Crescent	
Keystones and Voussoirs: a voussoir is a wedge-shaped element used in building an arch. A keystone is the central stone that locks all the stones into position, allowing the arch to bear weight. A keystone is often enlarged and embellished. Example: Queen Street South	
Lancet Window: a tall, narrow window with a pointed arch at its top. Example: St. Mary's Roman Catholic Church	
Mansard Roof: This style was popularized by Francois Mansart (1598-1666), an accomplished architect of the French Baroque period and especially fashionable during the Second French Empire (1852-1870). This roof is almost flat on the top section, with two slopes on each of its sides with the lower slope at a steeper angle than the upper and having dormer windows. Example: 28 Weber Street West	

Pilaster: a slightly projecting column built into or applied to the face of a wall for additional structural support. Example: downtown	
Quoin: masonry blocks at the corner of a wall, often a decorative feature, usually larger or of a different colour than the rest of the wall. Example: 73 Queen Street North, Prosecutors' Office	
Turret: a small tower that projects from the wall of a building. Example: Queen Street North	
Rose Window: a circular window with ornamental tracery radiating from the centre. Example: St. Mary's Roman Catholic Church	
Vergeboards: also called bargeboards (gingerbread) – hang from the projecting end of a roof and are often elaborately carved and ornamented. Example: 21 Ahrens Avenue	

Kitchener's Building Styles

Art Moderne, 1930-1945 – This style originated in the United States with rounded corners, smooth walls, and flat roofs. Large expanses of glass were used, even wrapping around corners. Example: 44 Weber Street West	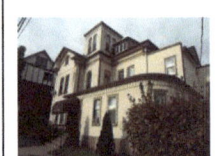
Beaux Arts: Promoters of this style sought to express the classical principles on a grand and imposing scale. Many of the Beaux Arts buildings were banks, post offices, and railway stations. The Ontario Beaux Arts style is eclectic mixing elements of Classical, Renaissance and Baroque. Often the designs have a temple-like façade, pedimented porticos, balustrades, capitals in many styles Example: Wilfrid Laurier University building	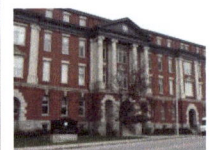
Edwardian, 1900-1930 – This style bridges the ornate and elaborate styles of the Victorian era and the simplified styles of the 20th century. Balanced facades, simple roof lines, dormer windows, large front porches, and smooth brick surfaces are its characteristics. Example: 68 Queen Street North – Knell House	
Georgian, before 1860 – This style began with the British King Georges in the 18th century. These buildings have balanced facades around a central door, medium-pitched gable roofs, and small paned windows. Example: 210 Pandora Crescent	

Gothic Revival, 1830-1890 – These decorative buildings have sharply-pitched gables with highly detailed vergeboards, pointed-arch window openings, and dichromatic brickwork. It is a common style in Ontario. Example: 180 Onward Avenue	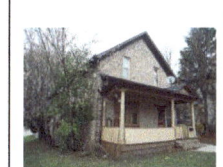
Italianate, 1850-1900 – It has wide-bracketed eaves, belvederes, wrap-around verandahs. Example: 51 Benton Street, Schreiter Sandrock Funeral	
Second Empire, 1860-1880 – The mansard roof is the most noteworthy feature of this style and is evidence of the French origins. Projecting central towers and one or two-storey bays can also be present. Example: 28 Weber Street West	
Tudor Revival – exposed timbers with stucco infill, multi-paned windows. Example: 222 Pandora Crescent	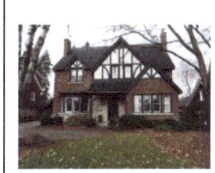

www.ingramcontent.com/pod-product-compliance
Lightning Source LLC
Chambersburg PA
CBHW040812200526
45159CB00022B/347